THE PASTELS BOOK

COLOURWORKS

THE PASTELS BOOK

DALE RUSSELL

PHAIDON · OXFORD

A QUARTO BOOK

Published by
Phaidon Press Limited
Summertown Pavilion
Middle Way
Oxford OX2 7LG

ISBN 0 7148 2714 2
ISBN 0 7148 2716 9 (boxed set of five in series)

First published 1991
Copyright © 1991
Quarto Publishing plc

A CIP catalogue record for this book is available from the British Library

This book was designed and produced by
Quarto Publishing plc
The Old Brewery, 6 Blundell Street
London N7 9BH

SENIOR EDITOR: Sally MacEachern
EDITOR: Paula Borthwick
DESIGNERS: Penny Dawes, David Kemp, Julia King
PICTURE MANAGER: Joanna Wiese
PICTURE RESEARCH ADMINISTRATION: Prue Reilly, Elizabeth Roberts
PHOTOGRAPHERS: Martin Norris, Phil Starling

ART DIRECTOR: Moira Clinch

Manufactured in Hong Kong by Regent Publishing Services Ltd
Typeset by Bookworm Typesetting, Manchester
Printed in Singapore by Tien Wah Press (Pte) Ltd

DEDICATION
With great love, I would like to thank my husband Steve for patiently guiding me through
the days and nights overtaken by colour and my daughter Lucy Scarlett for remaining
happy while colour came first.

CONTENTS

Using Colourworks

To make the most of the *Colourworks* series it is worthwhile spending some time reading this and the next few pages. *Colourworks* is designed to stimulate a creative use of colour. The books do not dictate how colour should be applied, but offer advice on how it may be used effectively, giving examples to help generate new ideas. It is essential to remember that *Colourworks* uses the four-colour process and that none of the colours or effects use special brand name inks.

The reference system consists of five books that show 125 colours, with 400 type possibilities, 1,000 halftone options, and 1,500 combinations of colour. But even this vast selection should act only as a springboard; the permutations within the books are endless. Use the books as a starting point and experiment!

When choosing colours for graphic design it is almost impossible to predict the finished printed effect. In order to save valuable time spent researching, you can use the series' extensive range of colours to provide references for the shade with which you are working.

The four process colours

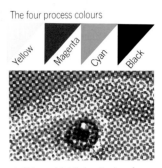

▲ Enlarged detail showing how four process colours overlap to produce "realistic" colour.

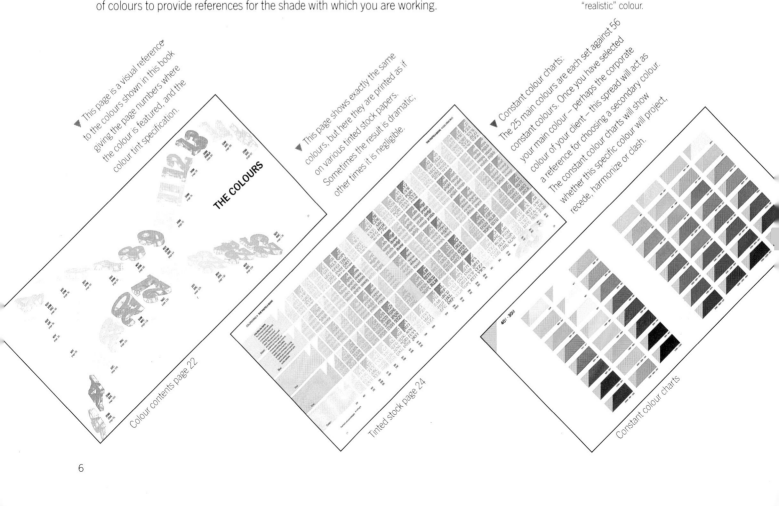

▼ This page is a visual reference to the colours shown in this book giving the page numbers where the colour is featured, and the colour tint specification.

Colour contents page 22

▼ This page shows exactly the same colours, but here they are printed as if on various tinted stock papers. Sometimes the result is dramatic; other times it is negligible.

Tinted stock page 24

▲ Constant colour charts: The 25 main colours are each set against 56 constant colours. Once you have selected your main colour – perhaps the corporate colour of your client – this spread will act as a reference for choosing a secondary colour. The constant colour charts will show whether this specific colour will project, recede, harmonize or clash.

Constant colour charts

The books are ideal for showing to clients who are not used to working with colour, so that they may see possible results. They will be particularly useful when working with a specific colour, perhaps dictated by a client's company logo, to see how this will combine with other colours. Equally, when working with several colours dictated by circumstances – and perhaps with combinations one is not happy using – you will find that the constant colour charts, colourways and applications will show a variety of interesting solutions. The numerous examples in *Colourworks* can act as a catalyst, enabling you to break out of a mental block – a common problem for designers who may feel that they are using a wide variety of colours but actually be working with a small, tight palette. Finally, when faced with a direct colour choice, you should use *Colourworks* in the same way you would use any other art aid – to help create the final image. The books are designed to administer a shot of adrenaline to the design process. They should be treated as a tool and used as a source of both information and inspiration.

TERMINOLOGY USED IN COLOURWORKS

Main colour: one of the 25 colours featured in each book.

Colourway: The main colour plus two other colour combinations.

Constant colour: The main colour with 56 constant colours.

Y: yellow
M: magenta
C: cyan
Blk: black
H/T: halftone
F/T: flat-tone

TECHNICAL INFORMATION

When using *Colourworks* or any colour specification book, remember that paper stock, lamination and type of ink can change the effect of chosen colours. Coated papers, high-quality especially, tend to brighten colours as the ink rests on the surface and the chalk adds extra luminosity, while colours on uncoated paper are absorbed and made duller. Lamination has the effect of making the colour darker and richer.

Colourworks specification

Colour bar GRETAG
Screen 150L/IN
Film spec.: AGFA511P
Tolerance level: +2% – 2%
Col. density: C=1.6−1.7
 M=1.4−1.5
 Y=1.3−1.4
 Blk=1.7−1.8
Ink: Proas
Paper: 130gsm matt coated art
Plate spec.: Polychrome
Dot gain: 10%
Printed on Heidelberg Speedmaster 102v
Printing sequence: Black/Cyan/Magenta/Yellow

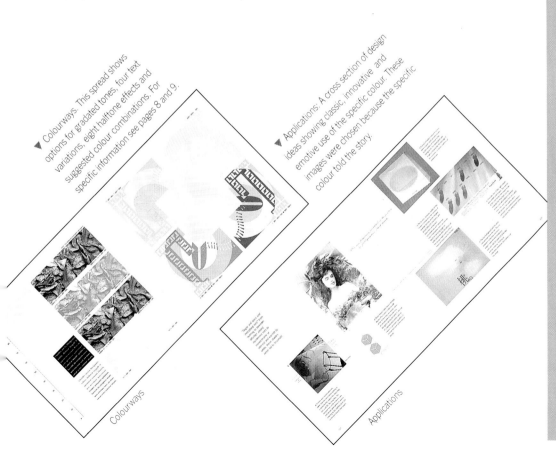

◄ Colourways. This spread shows options for gradated tones, four text variations, eight halftone effects and suggested colour combinations. For specific information see pages 8 and 9.

◄ Applications: A cross section of design ideas showing classic, innovative and emotive use of the specific colour. These images were chosen because the specific colour told the story.

Colourways

Applications

On the next four pages you can see, in step-by-step form, exactly how to understand and use the colour reference system shown in *Colourworks* and how you can incorporate the ideas into your designs.

It is essential to remember that *Colourworks* uses the four-colour process – none of the effects uses the special brand name ink systems – usually described as "second colours".

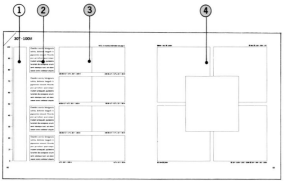

1. GRADATED COLOUR

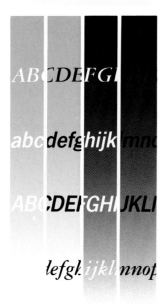

The colour scale shows the main colour fading from full strength to white. If you are using a gradated background, the scale clearly demonstrates at what point reversed-out-type would become illegible – with a dark colour you may be able to reverse out down to 20% strength, with a pastel only down to 80% or perhaps not at all, in which case the type should be produced in a dark colour.

The opposite would be true if the design incorporated dark type on a fading dark colour. Again, unless a very subtle result is required, the scale indicates at what point type would become illegible.

The other use of the fade gives the designer more colour options – perhaps you like the colour on page 102, but wish it was slightly paler. With the gradated shading you can visualize just how much paler it could be.

perhaps you like the colour on page 102

2. TYPE OPTIONS

The main colour with different type options: solid with white reversed out; type printing in the colour; black and the type reversed out as colour; solid with black type. These examples demonstrate the problems of size and tonal values of the type.

The type block is made up of two typefaces, a serif and sans serif, both set in two different sizes.

9pt New Baskerville
7pt New Baskerville

Ossidet sterio binignuis
gignuntisin stinuand. Flourida

trutent artsquati, quiateire
semi uitantque tueri; sol etiam

8½pt Univers 55
7pt Univers 55

Size

Using the four-colour process the designer obviously has no problems choosing any combination of tints when using large type, but how small can a specific colour type be before it starts to break up or registration becomes a problem? The type block shows when the chosen tints work successfully and more important *when they do not.*

Ossidet sterio binignuis
tultia, dolorat isogult it

9pt New Baskerville: 30% Mag demonstrates no problems.

gignuntisin stinuand. Flourida
prat gereafiunt quaecumque

7pt New Baskerville 40%Y 30%M 20%C the serifs start to disappear.

Tonal values

Obviously, when dealing with middle ranges of colour, printing the type black or reversed out presents no legibility problems. But the critical decisions are where the chosen colours and shade of type are close. Will black type read on dark green? Will white type reverse out of pale pink? When marking up colour, it is always easier to play safe, but using the information in *Colourworks* you will be able to take more risks.

Ossidet sterio binignuis
tultia, dolorat isogult it

Ossidet sterio binignuis
tultia, dolorat isogult it

The problem is shown clearly above: using a pastel colour (top) it would be inadvisable to reverse-out type; with a middle shade (centre) the designer can either reverse out or print in a dark colour; while using a dark colour (bottom), printing type in black would be illegible (or very subtle).

3. HALF-TONE OPTIONS

This section demonstrates some possibilities of adding colour to black and white halftones where the normal, realistic four-colour reproduction is not desired or when the originals are black and white prints. This section gives the designer 800 options using various percentages and combinations of the process colours.

The mood of the picture can be changed dramatically from hard edged photographs enhanced by a touch of colour to pale pastel tints suitable for backgrounds or decorative devices.

Each of the four options are shown using the main colour at full strength and at 50% strength. When specifying them to your colour separator make sure they understand what you are asking and clearly mark the *percentage* tint of each colour that you want. Also, emphasize whether it is a percentage of halftone or a flat tint that is required.

100% main colour

100% black H/T plus full strength of the main colour

50% strength of main colour

100% black H/T plus 50% of the main colour

50% black H/T plus full strength of the main colour

50% black H/T plus 50% of the main colour

100% black H/T plus a *flat* tint of the colour at full strength

100% black H/T plus a *flat* tint of the main colour at half strength

H/T using only the main colour at full strength

H/T using only the main colour at half strength

The photographs (left) have been marked up for origination using options from *Colourworks*. It is unusual to ask for a percentage halftone – make sure you mark it clearly.

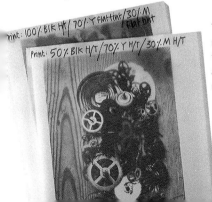

4. COLOURWAYS

This page shows the main colour with other colours. It acts as a guide to help the designer choose effective colour for typography and imagery. Each colour is shown as four colourways; each colourway shows the main colour with two others.

The three colours in each colourway (corner) are in almost equal proportions. The effect would change dramatically if one colour was only a rule or small area. Use the colourways to find the appropriate range for your design and adapt it accordingly.

For information on using the central square and its use in commissioning photography or illustration see page 10.

The choice of colour has not been limited to the safe options. The easy neutrals cream, white and grey have been used, but so have more unusual combinations.

The colours show various effects; look at each corner, if necessary isolating areas.

▼ Colours are shown projecting forwards sometimes using the laws of optics which say that darker, cooler shades recede.

▲ These are classic colour combinations.

▲ Colours that are similar in shade.

▲ Sometimes, due to the proportions, defying them.

abcdefghi

▲ Use these colours for background patterns, illustrations or typographic designs where the colour emphasis has to be equal.

▲ These colours are not advisable if your design needs to highlight a message.

Analyse your design to see how dominant the typography, illustrations, and embellishments need to be versus the background, then use the colourways to pick the appropriate colours or shades.

When selecting colours, it is very important to eliminate any other colour elements that might affect your choice. As has been demonstrated in the colour optics section (p.14), the character of a colour can be dramatically changed by other, adjacent colours.

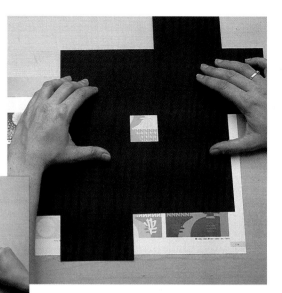

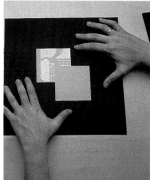

◀ ▲ The colourways have been designed in such a way that you can mask out the other colour options – isolating the area you want to work with or even small sections of each design.

▼ ▶ The colourways can also be used if you are selecting the colour of typography to match/enhance a photograph or illustration; again masking out the other colourways will help. A print of the photograph or illustration can be positioned in the central area, and the mask moved around.

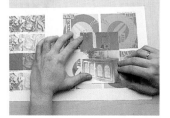

Useful mask shapes

The design shown on this page was created to demonstrate the practical use of *Colourworks*. It combines many halftone effects and colour combinations.

The options illustrated are drawn from *The Pastels Book*. For more suggestions and further inspiration, refer to the other books in the series.

► Using elements from *The Pastels Book* pages 96-97, 98-99.

Nos amice et nebevol

R Ossidet ignis multa, dolorem oculis quae gignunt insinuando. Lurida praeterea fiunt quaecumque tuentur arquati, quia luroris de corpore eorum semina multa fluunt simu uitantque tueri; sol etiam caecat, contra si tendere pergas propterea quia uis magnast ipsius, et alte aera per purum grauiter simulacra feruntur, et feriunt oculos turbantia composituras. Praeterea

Ectamen nedue enim haec movere potest pellat sensar luptae epicur semper hoc

Nos amice et nebevol

R Ossidet ignis multa, dolorem oculis quae gignunt insinuando. Lurida praeterea fiunt quaecumque tuentur arquati, quia luroris de corpore eorum semina multa fluunt simu uitantque tueri; sol etiam caecat, contra si tendere pergas propterea quia uis magnast ipsius, et alte aera per purum grauiter simulacra feruntur, et feriunt oculos turbantia composituras. Praeterea

Ectamen nedue enim haec movere potest pellat sensar luptae epicur semper hoc

◄ Using elements from *The Pastels Book* pages 40-41, 42-43.

11

Pastels introduction

" *A pale delicate colour.* **"**

Collins English Dictionary, Publishers, William Collins Sons and Co. Ltd., London & Glasgow; Second Edition 1986

" *Pale and light in colour.* **"**

Webster's Ninth New Collegiate Dictionary, Merriam-Webster Inc., Publishers, Springfield, Massachusetts, U.S.A., 1983

Colour is not tangible; it is as fluid as a musical note. Although it may be described, the verbal or written words often bear no relation to its actual form. Colour has to be seen in context, for a single shade used in conjunction with another colour can take on a whole new character. Searching for a particular shade can be very confusing – somewhat like humming a tune and searching for a forgotten note.

No matter how much theory exists, it is the eye of the designer or artist that is responsible for using colour creatively. The fact that colour can be rationalized and then break its own rules with complete irrationality is what makes it so fascinating.

This book is about process colour. By the very nature of the process system, colours are not blended, as with pigments, but shades are selected visually by percentage. Unlike pigment colours, process colours can be mixed without losing any of their chromas. The process primary colours are magenta, yellow, and cyan, with black to create density and contrast, allowing dot saturation to establish values of lightness and darkness. The pigment primaries are red, blue and yellow.

The concept of process colour is not really new. The German poet and scientist Goethe (1749-1832) looked at effects of light and darkness on pigment colour in a way that strongly relates to modern interpretation of process colour. In complete contrast, a practical approach was taken by the 20th-century German painter Hickethier, who created a precise notation system based on cyan, magenta, and yellow for printing. Between these two extremes lies the concept of the process colour system.

The colours used in these books had to be systematically chosen to prevent *Colourworks* from dating or the colours from being a purely personal choice. It was important to rely on theory and I finally selected over a thousand colours for the five books that make up this series. This meant working with literally thousands of colours, and yet in spite of this comprehensive palette, there would still be a precise shade that would remain elusive.

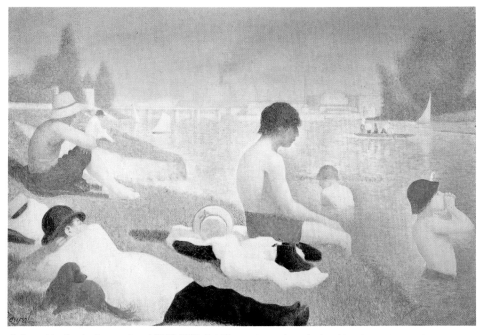

Bathers at Asnières by Georges Seurat (1859-1891). Pointillism, using a colour wheel to determine precise complementary shades, evokes the heat of a summer day.

My next major task was to select each image from advertising agencies, design consultancies, illustrators and actually "off the walls". Every piece of printed matter, label, carrier bag or magazine was a potential gold mine of material for the books. Many images had to be excluded, even though they had superb colouration, because they did not tell a story with one predominant colour.

Colourworks examples had to have immediate impact, with one colour telling the story—whether in harmony with others, through shock tactics, providing a backdrop, creating a period setting, making instant impact for the recognition of the image content, or simply combining superb use of colour with design.

Colour combinations are infinite, and every day wonderful examples of colour and design are being created. Having drawn from just some of these images, I hope that the *Colourworks* series will become a reference to inspire, confirm and enjoy.

Dale Russell

Optical illusion, proportion and texture

Pastel colours are literally tints of solid colour; they are a lower percentage of the one-hundred per cent shade. In *Colourworks*, pastel colours have been determined at a colour saturation of below fifty per cent. We therefore, in many cases, follow the theories and practices of the primaries magenta, cyan and yellow discussed in the other books of the *Colourworks* series. For instance, in *The Blue Book*, there is mention of shades of blue having immediate connotations with sky and water. These associations can still be applied to the pastel shades of blue shown in this book. But a shade such as lilac has a specific set of associations.

Pastels can make objects appear larger in size and yet lighter in weight. They blend with light to create a clean, unobtrusive atmosphere. By their very nature, pastels are perfect as a background colour, allowing the more saturated tints to perform in the foreground. However, they can also be used effectively when applied to a foreground, highlighting imagery and typography.

By applying the slightest of pastel tints the glare of a white page can be subtly broken, creating an impression of texture without dominating. Pastel tints can also be used behind typography or graphics to highlight specific statements or facts. Several tones of either the same or differing pastels can create movement on a graph or graphics.

▲ In a complex and delicate design the illusion of a shadow cast over part of the page is created through tints. This is extremely sparingly applied, and yet it is not lost among the intricate detail, which has a highly textured, almost three-dimensional quality. The colours chosen blend softly together, giving the impression of mottled lilac-grey, which in turn makes the white warm rather than harsh. The addition of cobalt gives further dimension and added warmth to the background.

▲ Texture and the illusion of texture are created by the use of colour and collage. The harmonious tones of peach and white form a textural background through light and shade intensities for the dominant ochre red application of plaits. The plaits appears to bleed a soft tint of terracotta onto the background. The addition of another colour scheme behind "RIO" seems incongruous but strengthens the textured harmony of the entire page, while highlighting the name.

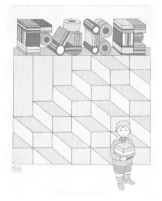

▲ An Escher-like approach gives a sophisticated touch to what could have been a very saccharine design. Variations of two key colours make a complex design appear simple, with illusions of depth and height.

▲ The red ochre of the abstract design is used again in the chart, but this time it assumes a dominant role. The soft pastel tint of this shade provides harmony. A soft grey tones with the third shade of red ochre.

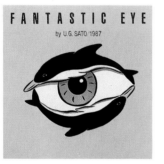

▲ The soft pink background makes it possible to see two images at once. The strong, predominantly black and white illustration of two dolphins swimming around a ball is immediately recognizable. At the same time, the natural association of the pink with human skin tones enables us to see an eye. The soft harmony of the blue and green sphere relates to the pastel pink, while the black typography and the eye/dolphins project from it.

▲ The use of pastels, applied to the page in broad strokes of colour to create defined areas, is both effective and artistically pleasing. The choice of blue as a background to the text, while primrose and peach sorbet highlight the images, makes the page eye-catching and easy to read. At the same time, it creates a sense of space and depth that takes the page into a further dimension.

▲ ▲ Deep, moody shades, combined with abstract design, create dramatic impact. The atmosphere relies upon the textured application of line and colour, as well as the contemporary palette.

▲ The palest of peach backgrounds floats the imagery, while "shelves" created by chrome yellow give stability to the design. The colours have the feel of middle-tone nursery shades but, in fact, include much stronger hues.

Psychology

Pastels can be bright and childlike or subtle and
romantic. They can suggest cleanliness and
purity or lightness and simplicity; or they
can be cloyingly sweet. The word "pastel"
tends to evoke a stereotyped image of
female domesticity, but, in fact, most
pastels including pale green and fawn are
natural colours that appeal to both sexes.

Pastels imply the gentle aspects of nature. They
are traditionally associated with newborn
babies and fluffy yellow chicks. The colours
are also reflected in the regeneration of the
spring countryside with the pinks of
blossom and primroses among the new
growing grass.

There is also, however, a sickly side to pastels.
The sight of sugar pink can still bring back
memories of candy-floss and roller coasters
– of children's birthday parties and their
aftermath.

In general, pastels are harmonious, restful and
relaxing; they are easy on the eyes and
allow the subject to filter through gently.

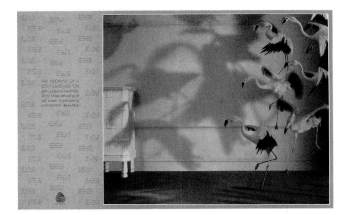

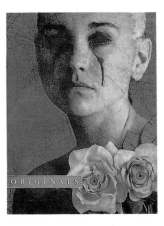

▲ The blue tint relates to
sadness and depression. It
also has associations with
Picasso's "blue period" in
this image. The strong
psychological message of
unhappiness is then given
further implications of unease,
and a sense of the macabre,
by the apparant reversal of
colour. The surreal tear (or is it
blood?) takes the eye to the
gentle pink of the roses. It is
then that we become aware of
the pale blue eyes staring
from the centres.

▲ This advertisement
incorporates the
psychological associations
between colour and imagery.
The "soft landing" is created
in burnt sienna against the
pastel pink of the warm and
gentle image. We are
reassured that the delicate
legs of the birds can safely
land. The salmon tint to the
flamingoes' feathers, with
their accent of black, forms a
sympathetic link between the
baby pink and the sienna
carpet.

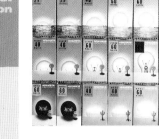

Minale, Tattersfield Corporate & Financial Communications

▲ Soft and relaxing shades create an atmosphere of comfort and security. The message also has great clarity, due to the contrast of cheerful apricot against the harmonious shades of lilac. These colours, with their complementary clarity, tend to appeal to the elderly. However, the approach to the design and colour is contemporary and not condescending.

▲ ▲ Marketing has used the psychological reactions associated with colour as the main theme for this packaging. The use of a deep pastel tint to recreate the atmosphere associated with melting heat, arid desert and different degrees of light against land and water is highly effective.

▲ The literal use of colour is employed to great effect. The strength of the waterfall is increased by tint. The pure white cover gives the blue, greater impact. The blue panel and logo confirm the power of water.

▲ The psychological association between money and the pink of *The Financial Times* in the mind of the British reader has given a creative opportunity to the designer of this financial document. The textured effect of rubbing wax crayon on paper over a coin playfully echoes the company's own logo. The witty application of this design to the pink of the newspaper makes an ideal cover for the company's own financial report.

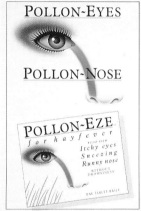

▲ The misery of hay fever is immediately conveyed by the colour and graphics. The subtlety of the small percentage of geranium tint in the eye gives way to a more intense shade of geranium in the nostril. The soft graphite around the lids gives impact and strengthens the pink tint of the irritation, while the gentle strokes of grass green reveal the allergy source.

Marketing

The term "pastels" actually covers a very wide palette, ranging from pale sugar almond pink to sophisticated greyed yellows and beiges. Pastels can be bright and candy-coloured as well as soft and romantic.

Displays, packaging, and signs using soft pastel shades tend to lose impact in strong light and are therefore not suitable for sunny climates. The same hue, a few shades darker, may prove an effective alternative.

Pastels can be used for a wide range of products. The sugar shades of pastels are the obvious choice for confectionery; turquoise can be clinical; light green and blue are equally suitable for the extremes of the business world and that of children's clothes and products. The family of beiges and fawns may create a feeling of warmth and softness, yet used in isolation can convey a bleak neutrality. Pink and peach are feminine colours which are commonly used for cosmetics.

Food packaging often uses pastels; they have a fresh, clean appearance which is less aggressive than rich colours and friendlier than stark white.

In addition to these traditional associations, there is a growing use of more obscure colour mixing of pastels by contemporary designers. An original approach can be achieved by using the less common secondary pastels, such as pale olive and muted orange; by combining tangent hues such as lilac and primrose; or simply by applying a pastel that is discordant with the saturated tone.

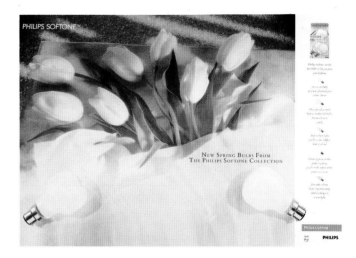

NEW SPRING BULBS FROM
THE PHILIPS SOFTONE COLLECTION

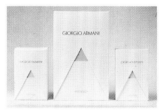

▲ The elegance of the subtle hint of pastel yellow enhances the minimalist sophistication of the packaging, which recreates the initial letter of the designer's name. A secondary harmonious shade appears within the central triangle of the letter, revealing the product contained within the package.

▲ The subtlest of pastel tints are overlaid onto a pure white background. The colour is so minimal that the effect is almost that of a hand-tinted monochrome image. The gentleness of the colour is the subject of the caption, and the title of the product, "Softone Collection". This concept is reinforced by the delicate pastel tones around the bulbs. Marketing uses the association between spring flower bulbs and the pastel-coloured lightbulbs to create a memorable image.

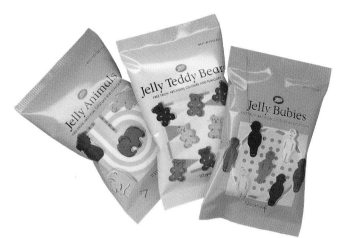

ON NE DEMANDE PAS L'ÂGE D'UNE FEMME.ON NE DEMANDE PAS LE PRIX DE SES CHAUSSURES.

stephane kélian.

▲ Pastel shades are associated with sweets and children. The choice of tonal shades for the packaging conveys the idea of a series, and yet allows individual identity for the varied contents. These packets are designed to appeal not only to children but also to parents, for their colour palette implies purity and freshness. The pastels project the stronger colours of the jelly sweets, while providing appealing backgrounds.

▲ The complexity and intricacy of the pastel tints against indigo linear graphics catches the eye while promoting the many possible applications associated with the paper. The quality of the printing and texture in conjunction with the 3-D aspect of the image tell the story. The text becomes secondary — essential when an advertisement is often just glanced at by readers.

▲ ▲ Elegance, quality of craftsmanship and the use of natural materials are conveyed in this sophisticated and understated advertisement. The textural lilac-grey marble background complements the polished, rich tan of the leather. The pastel shade evokes the atmosphere of a piazza and the world of haute couture.

▲ Pastels have been used to create a new approach to designing brochures that relate to the stock market. By linking these shades to the background pink of *The Financial Times* the colour palette is explained. The juxtaposition of these soft shades with a sober mole grey gives them authority and stability; the repetition of this palette in a series of brochures provides continuity.

Culture and period

Although found in nature, within the written history of organic colour pastels are comparatively "new" colours; they are attenuated forms of the saturated shades. In Britain, the Regency period (early 1800s) favoured light green; earlier, Georgians were particularly fond of the strongest of pastels, such as buttercup yellow and bright pink. The Victorians used an extensive range of colours, though favouring tints of violet, such as lilac, and mauve.

The 1920s and, more specifically, the thirties featured pastels in both printing and fashion. Colour combinations such as orchid and *eau de nil* were extremely popular, as was the juxtaposition of strong deep colours and pastels – burgundy and fawn, for example.

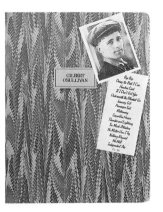

▲ Here is an "album" cover in more than one sense of the word. The recreation of an early 20th-century photograph album is achieved primarily by the use of appropriate colours for the period. The hand-marbled effect of a period book, or album, is given greater authenticity by the choice of shades of brown, rather than different hues. The toning of fawn into the intensities of Havana brown suggests the era, while the monochrome photography and handwritten text are given visibility.

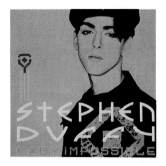

▲ This design has a contemporary originality which draws on other periods without sacrificing modern individuality. Pastels have been taken into a subterranean palette, as four discordant shades complement one another while vying for visibility.

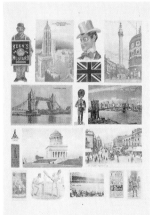

▲ A montage of period scenes of England is given unity and authenticity by the muted palette of pastel shades. These soft yellowed tones from the red family create the illusion of sepia and age without losing impact.

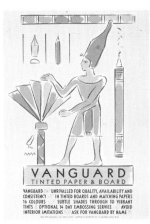

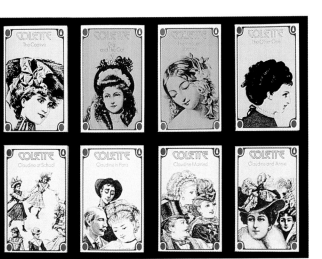

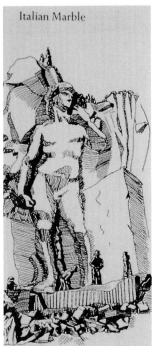

Italian Marble

▲ Ancient Egypt is captured in the pastel palette. The graphic images are true in feeling and style to the wall decorations of this early civilization. The liveliness of the pastel shades is further activated by the choice of cadmium primrose against oxblood for the title banner. The background of a low percentage yellow tint gives warmth while defining the "wall" background.

▲ This Art Deco design is entirely faithful to the colours that were in vogue during the 1920s and thirties: shell pink, aqua and primrose on black. The days when shopping was enjoyed in a more leisurely way are recreated within this design through graphics and colour imagery.

▲ A series of books by Colette have illustrative portraits as the cover graphics. They set the period immediately with the quiet authority given by the appropriate colours. The combination of illustrative content and the chosen colourways creates two series. The first "series" has a single portrait which has been given individuality by the application of a single pastel shade. These pastels harmonize but retain their own character. The second "series" has several portraits on each cover, while retaining the theme of black on white. The two "series" are connected by the burnt orange of the publisher's logo in one corner that is echoed in the other three corners.

▲ Renaissance Italy is portrayed in marble. By applying linear graphics onto the colour of marble, the designer has created a strong imagery for the product in the subtlest of ways. The shell pink background allows the black image to form a textural effect while retaining the colouration of marble.

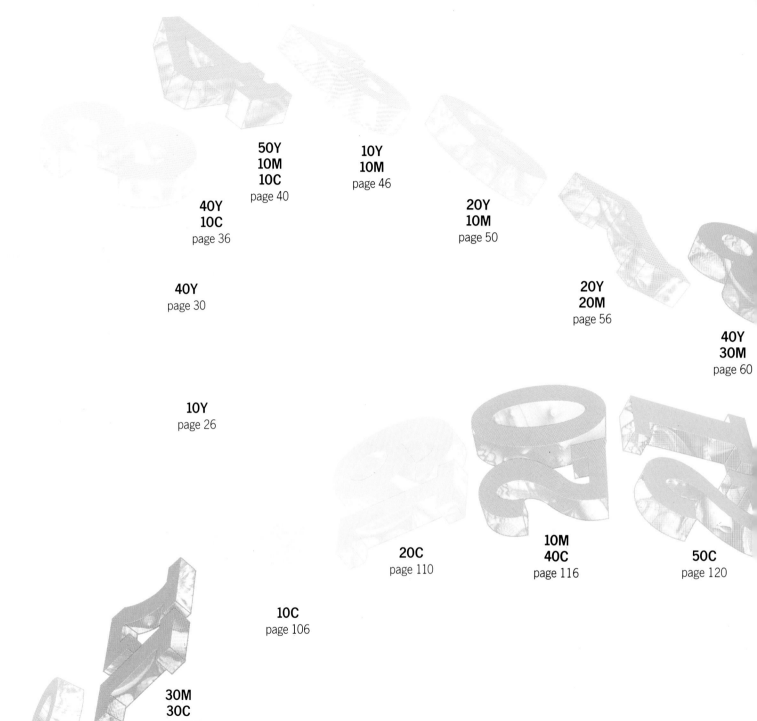

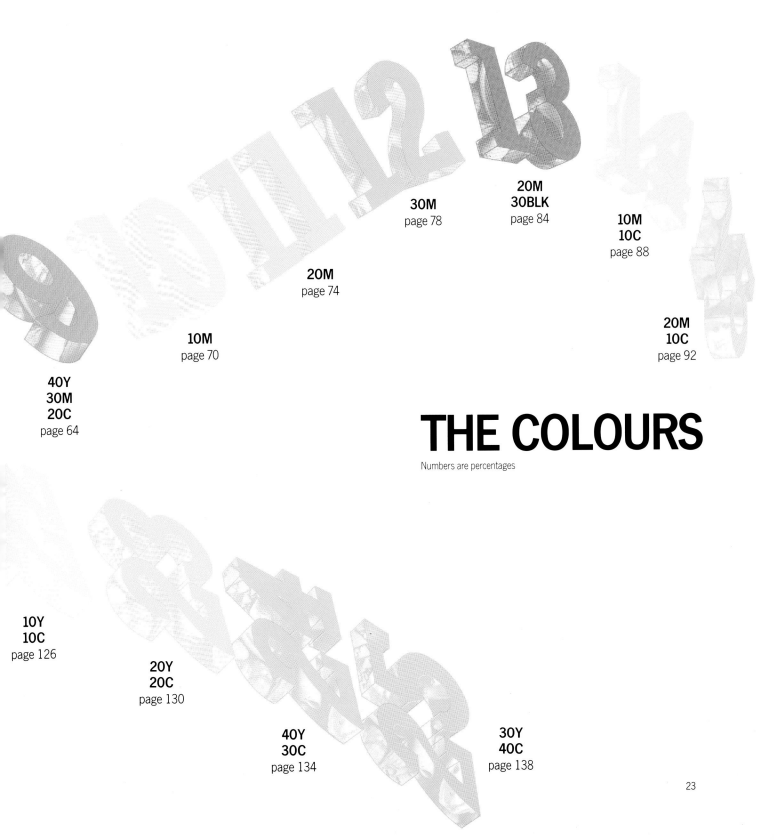

THE COLOURS

Numbers are percentages

COLOURS ON TINTS

The 25 main colours are printed on background tints to simulate the effect of printing colour on printed stock. This chart can be used in a number of ways: as a guide to see how pale your chosen colour can go before it merges with the printed stock; to determine the aesthetic advantages of using a particular colour on a specific stock and to experiment with subtle patterns.

The corner flashes (triangles) show the main colour in its pure state, while the lettering shows the colour printed on the tint.

Green

Blue

Pink

Grey

Cream

	10Y	40Y	40Y 10C	50Y 10M 10C	10Y 10M	20Y 10M	20Y 20M	40Y 30M	40Y 30M 20C	10M	20M

Numbers are percentages

M	20M	10M	20M	20M	30M	10C	20C	10M	50C	10Y	20Y	40Y	30Y
	30BLK	10C	10C	20C	30C			40C		10C	20C	30C	40C

20M

40Y

30M · 20C

40M · 10Y

60Y

40M · 30C

50M · 20Y

80Y

50M · 40C

70M · 40Y

100Y · 10M

60M · 50C

80M · 40Y

100Y · 20M

70M · 60C

90M · 50Y

100Y · 40M

80M · 70C

100M · 80Y

100Y · 20M · 10C

90M · 80C

100M · 80Y · 20C

100Y · 40M · 20C

100M · 100C

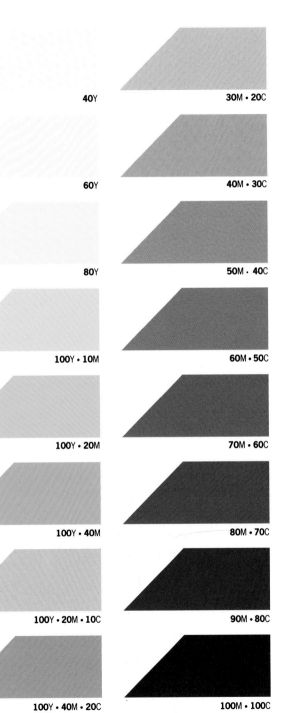

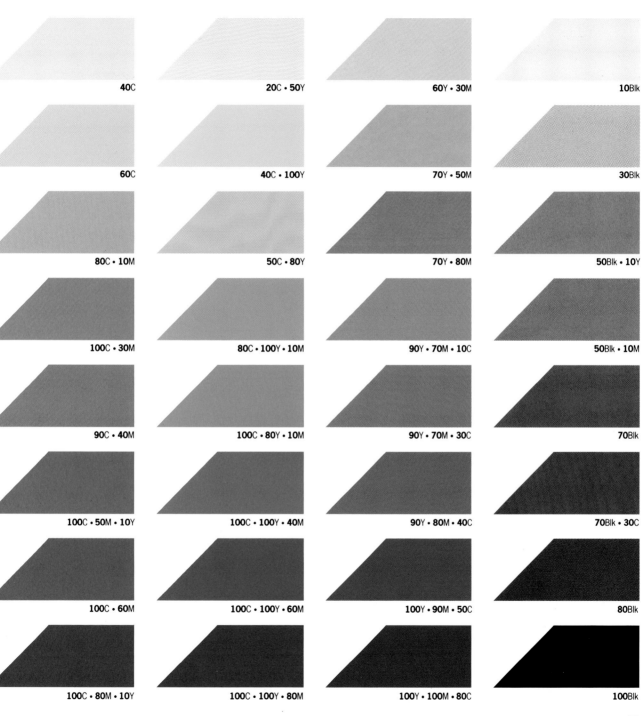

40C	**20**C • **50**Y	**60**Y • **30**M	**10**Blk
60C	**40**C • **100**Y	**70**Y • **50**M	**30**Blk
80C • **10**M	**50**C • **80**Y	**70**Y • **80**M	**50**Blk • **10**Y
100C • **30**M	**80**C • **100**Y • **10**M	**90**Y • **70**M • **10**C	**50**Blk • **10**M
90C • **40**M	**100**C • **80**Y • **10**M	**90**Y • **70**M • **30**C	**70**Blk
100C • **50**M • **10**Y	**100**C • **100**Y • **40**M	**90**Y • **80**M • **40**C	**70**Blk • **30**C
100C • **60**M	**100**C • **100**Y • **60**M	**100**Y • **90**M • **50**C	**80**Blk
100C • **80**M • **10**Y	**100**C • **100**Y • **80**M	**100**Y • **100**M • **80**C	**100**Blk

NOTE: For technical information see page 6

100
90
80
70
60
50
40
30
20
10
0

100Blk H/T • H/T's: **10**Y 100Blk H/T • H/T's: **5**Y

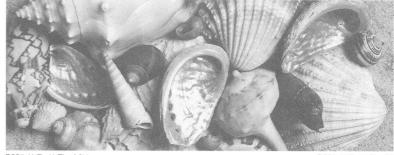

50Blk H/T • H/T's: **10**Y 50Blk H/T • H/T's: **5**Y

Ossidet sterio binignuis tultia, dolorat isogult it gignuntisin stinuand. Flourida prat gereafiunt quaecumque **trutent artsquati, quiateire lurorist de corspore orum** semi uitantque tueri; sol etiam caecat contra osidetsal utiquite

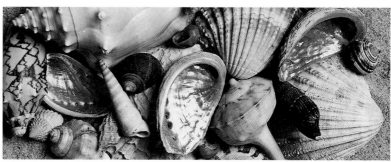

100Blk H/T • F/T's: **10**Y 100Blk H/T • F/T's: **5**Y

Ossidet sterio binignuis tultia, dolorat isogult it gignuntisin stinuand. Flourida prat gereafiunt quaecumque trutent artsquati, quiateire lurorist de corspore orum semi uitantque tueri; sol etiam caecat contra osidetsal utiquite

H/T's: **10**Y H/T's: **5**Y

30Y • 10C 40Y • 30M

10C 10M

70Y • 80M 80M • 100Blk

70Y • 60M • 100C 90C

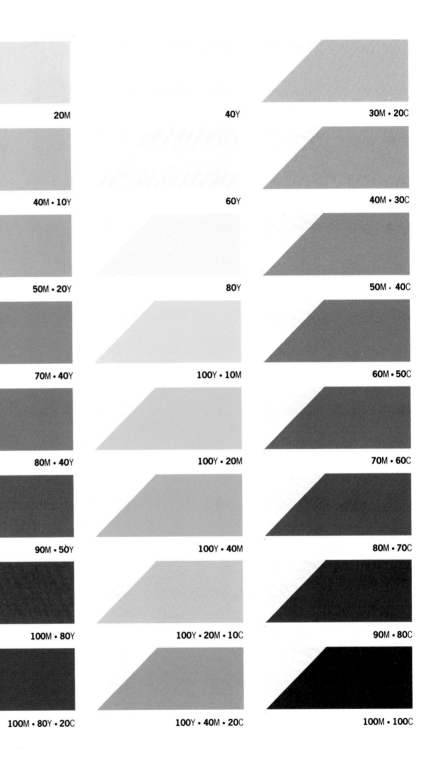

20M

40Y

30M · 20C

40M · 10Y

60Y

40M · 30C

50M · 20Y

80Y

50M · 40C

70M · 40Y

100Y · 10M

60M · 50C

80M · 40Y

100Y · 20M

70M · 60C

90M · 50Y

100Y · 40M

80M · 70C

100M · 80Y

100Y · 20M · 10C

90M · 80C

100M · 80Y · 20C

100Y · 40M · 20C

100M · 100C

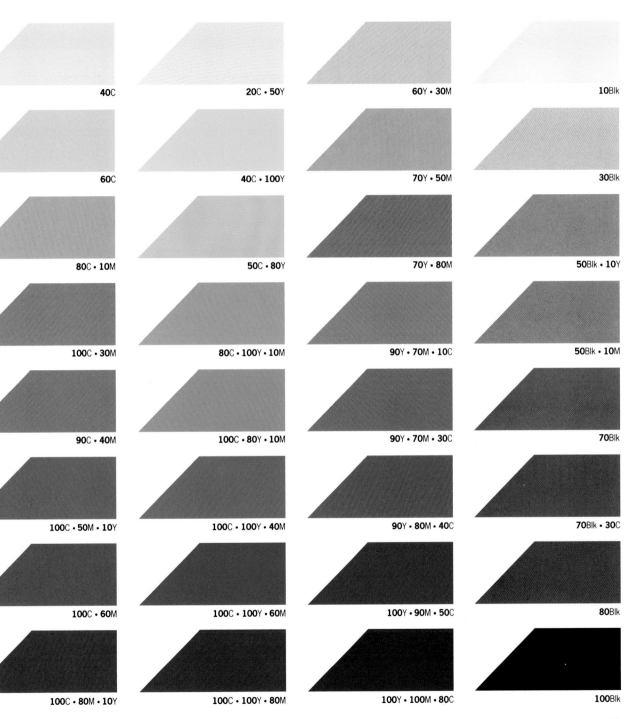

40C	20C · 50Y	60Y · 30M	10Blk
60C	40C · 100Y	70Y · 50M	30Blk
80C · 10M	50C · 80Y	70Y · 80M	50Blk · 10Y
100C · 30M	80C · 100Y · 10M	90Y · 70M · 10C	50Blk · 10M
90C · 40M	100C · 80Y · 10M	90Y · 70M · 30C	70Blk
100C · 50M · 10Y	100C · 100Y · 40M	90Y · 80M · 40C	70Blk · 30C
100C · 60M	100C · 100Y · 60M	100Y · 90M · 50C	80Blk
100C · 80M · 10Y	100C · 100Y · 80M	100Y · 100M · 80C	100Blk

NOTE: For technical information see page 6

100

90

80

70

60

50

40

30

20

10

0

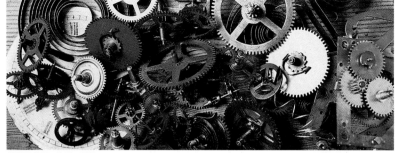

100Blk H/T • H/T's: **40**Y 100Blk H/T • H/T's: **20**Y

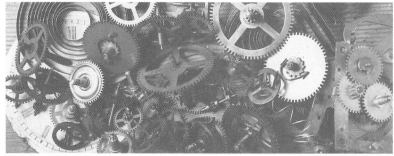

50Blk H/T • H/T's:**40**Y 50Blk H/T • H/T's: **20**Y

Ossidet sterio binignuis
tultia, dolorat isogult it
gignuntisin stinuand. Flourida
prat gereafiunt quaecumque
trutent artsquati, quiateire
lurorist de corspore orum
semi uitantque tueri; sol etiam
caecat contra osidetsal utiquite

100Blk H/T • F/T's: **40**Y 100Blk H/T • F/T's: **20**Y

Ossidet sterio binignuis
tultia, dolorat isogult it
gignuntisin stinuand. Flourida
prat gereafiunt quaecumque
trutent artsquati, quiateire
lurorist de corspore orum
semi uitantque tueri; sol etiam
caecat contra osidetsal utiquite

The faintest tint of yellow creates texture when white is too harsh, harmonizes with shades of green and black, and is a perfect foil for red.

▶ In keeping with a book on calligraphy, the combination of pattern with such a gentle shade of yellow becomes evocative of the textural effect of handmade paper.

▼ Immediate product recognition is achieved through the application of yellow which is generally associated with dairy products. This shade of primrose, combined with the powerful use of pastel graphics creates an atmosphere of alfresco eating on a sunny day.

▲ The palest of cream tints forms a sympathetic background for the soft green and crimson of the botanical illustration. When combined with the classic black typeface it creates a restrained and traditional dust jacket.

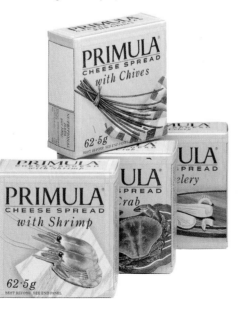

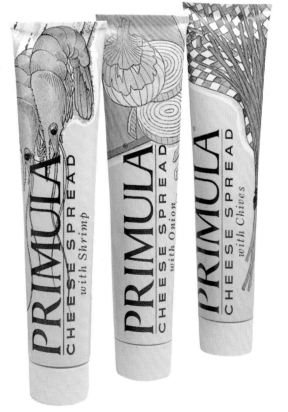

crack busters

America may be losing the war against drugs, but in New York and Washington, members of the Muslim community have taken the fight against 'crack' into their own hands ...

REPORT BY HUGH MORLEY
PHOTOGRAPHS BY LILLIAN CARUANA

"That brother Seen, I'd love to have a go at him when this – the Ramadan fast – is over, when I'm stronger," says Yusef Abdullah, bristling in the night air. "These hands are licensed, you know – 4th Day I die." His stare shifts in the dim light as he pulls out a laminated plastic card that testifies to his credentials as a former boxer and trainer, and he stares down the murky street at a twenty-four-hour launderette – a suspected crack-supply location run by two brothers – and the handful of shadowy figures hanging around outside.

It is 4:35 on a chilly May Saturday night, and Abdullah is on the graveyard shift of a Muslim anti-crack patrol in the Bedford-Stuyvesant sector of Brooklyn, New York. For the last five months, the Muslims have kept a twenty-four-hour watch on a 200-yard stretch of Fulton Street, a main thoroughfare into the area which houses their At-Taqwa mosque. Such has been the patrol's success that there is now scant sign of the drug trading that once scarred this street.

By day, a berating caretaker, Abdullah runs through the remaining trouble-spots on the street, recounting their recent history. He points to a Jamaican grocery – a site known for its drug dealing, with a revolving yellow beacon light marking its entrance – where some days earlier, six Muslims had placed themselves around the door while two were unable to instigate the corner for the ruse of his scrutiny. Behind it a late-night discount hardware store catering to a stream of ragged customers, its owners receive constant pressure from the Muslims to stop the sale of the glass tube 'stems' designed for smoking crack-stems which they are legally entitled to stock. Halfway up the street is the launderette, suspicious for the stream of strangers who pull up in their flashy Nissan Maxims and BMWs and then disappear inside. More suspicious still are its generous opening hours. "Have you ever heard of a twenty-four-hour 'launderette'?" scoffs Abdullah.

As the biggest ghetto in Brooklyn, the Bedford-Stuyvesant area has played a key host to the crack trade which has swept New York over the past two years. This particular stretch of Fulton Street, dominated by derelict shopfronts with abandoned apartments above, has provided the site for an estimated fifteen crack-houses, each with a daily turnover of $10,000. Residents and shopkeepers have been forced to endure the crime that accompanies the brazen drug dealings – muggings, prostitution, robberies and shoot-outs – and so have the Muslims who gather in the mosque in the corner. They describe the alarming escalation of crime on the street over the last

BLITZ 33

◄ Blood-red typography on a pure cream tint is symbolic of blood spilled through drug abuse and the colour of illegal drugs. This choice of background gives power and clarity to the type, while lending a strong atmosphere of photorealism to the monochrome photography.

▼ This colour combination evokes the 1940s but has a contemporary application. A linear approach to a colour palette of black, white and kingfisher, with hints of palest yellow, is immediately suggestive of the underwater scene so atmospherically portrayed. The palest of lemon yellows forms the bright central spotlight.

▶ An industrial approach to a nautical theme and colour combination allows both a forceful typographic statement and strong graphic illusion. An application of ten percent process yellow against sage green suggests underwater lighting. The soft, glowing yellow light projects the black type within the porthole, yet when these colours are reversed still brings clarity to the typography in this contemporary design.

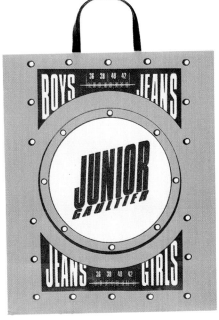

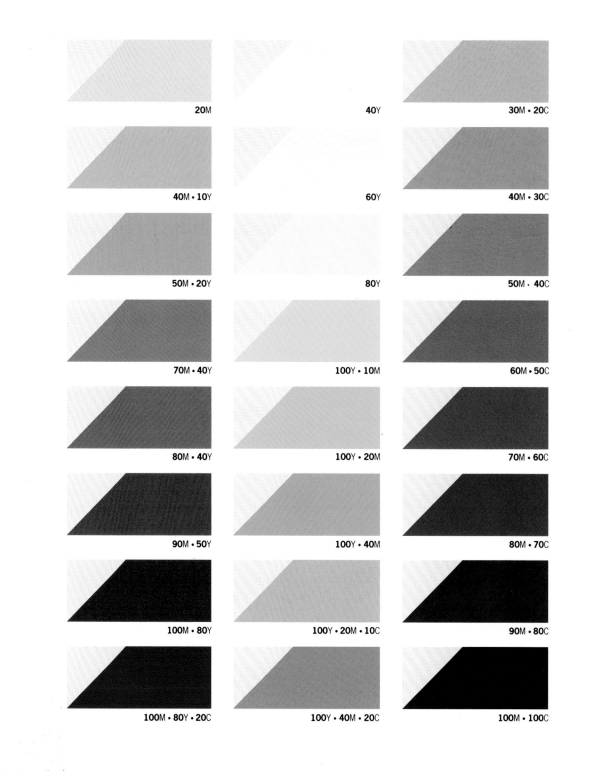

20M

40Y

30M · 20C

40M · 10Y

60Y

40M · 30C

50M · 20Y

80Y

50M · 40C

70M · 40Y

100Y · 10M

60M · 50C

80M · 40Y

100Y · 20M

70M · 60C

90M · 50Y

100Y · 40M

80M · 70C

100M · 80Y

100Y · 20M · 10C

90M · 80C

100M · 80Y · 20C

100Y · 40M · 20C

100M · 100C

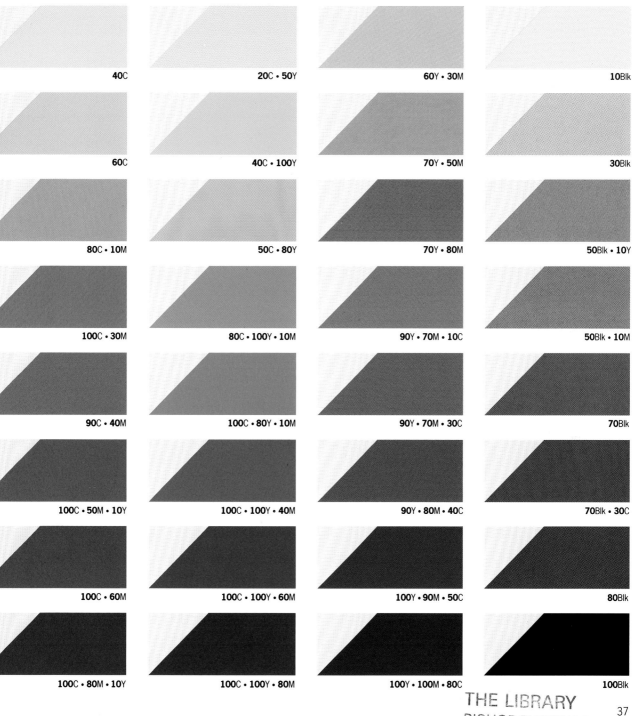

40C	20C • 50Y	60Y • 30M	10Blk
60C	40C • 100Y	70Y • 50M	30Blk
80C • 10M	50C • 80Y	70Y • 80M	50Blk • 10Y
100C • 30M	80C • 100Y • 10M	90Y • 70M • 10C	50Blk • 10M
90C • 40M	100C • 80Y • 10M	90Y • 70M • 30C	70Blk
100C • 50M • 10Y	100C • 100Y • 40M	90Y • 80M • 40C	70Blk • 30C
100C • 60M	100C • 100Y • 60M	100Y • 90M • 50C	80Blk
100C • 80M • 10Y	100C • 100Y • 80M	100Y • 100M • 80C	100Blk

37

40Y · **10**C

NOTE: For technical information see page 6

100

90

80

70

60

50

Ossidet sterio binignuis
tultia, dolorat isogult it
gignuntisin stinuand. Flourida
prat gereafiunt quaecumque
trutent artsquati, quiateire
lurorist de corspore orum
semi uitantque tueri; sol etiam
caecat contra osidetsal utiquite

40

30

Ossidet sterio binignuis
tultia, dolorat isogult it
gignuntisin stinuand. Flourida
prat gereafiunt quaecumque
trutent artsquati, quiateire
lurorist de corspore orum
semi uitantque tueri; sol etiam
caecat contra osidetsal utiquite

20

10

0

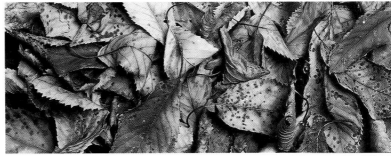

100Blk H/T • H/T's: **40**Y • **10**C 100Blk H/T • H/T's: **20**Y • **5**C

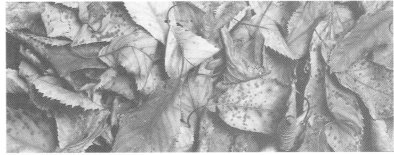

50Blk H/T • H/T's: **40**Y • **10**C 50Blk H/T • H/T's: **20**Y • **5**C

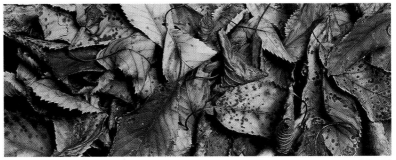

100Blk H/T • F/T's: **40**Y • **10**C 100Blk H/T • F/T's: **20**Y • **5**C

H/T's: **40**Y • **10**C H/T's: **20**Y • **5**C

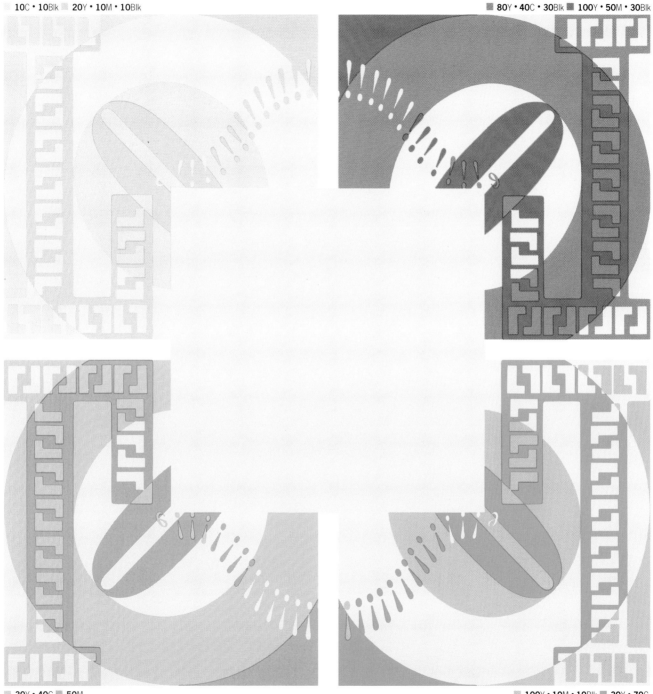

50Y · 10M · 10C

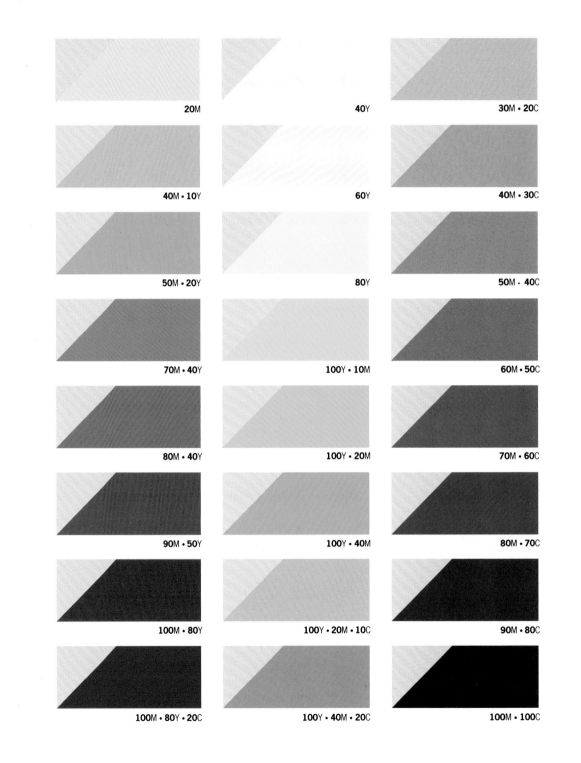

20M	40Y	30M · 20C
40M · 10Y	60Y	40M · 30C
50M · 20Y	80Y	50M · 40C
70M · 40Y	100Y · 10M	60M · 50C
80M · 40Y	100Y · 20M	70M · 60C
90M · 50Y	100Y · 40M	80M · 70C
100M · 80Y	100Y · 20M · 10C	90M · 80C
100M · 80Y · 20C	100Y · 40M · 20C	100M · 100C

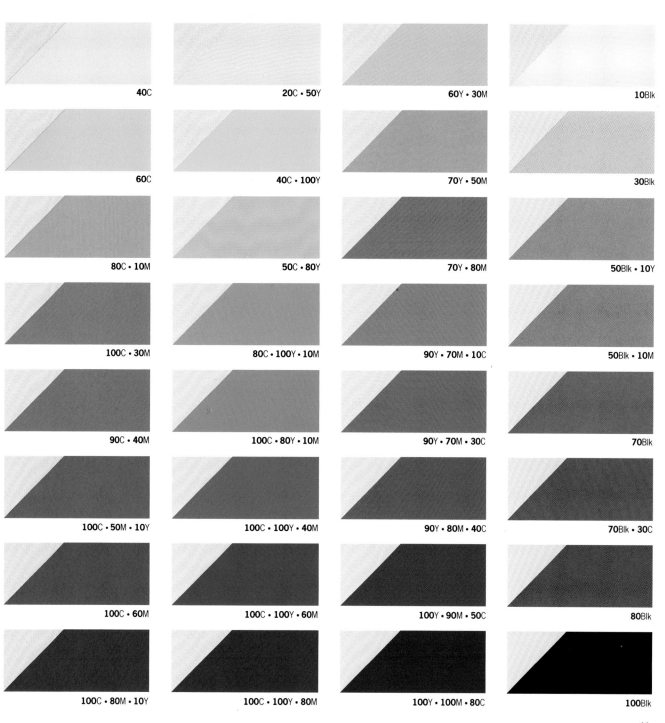

40C

20C · 50Y

60Y · 30M

10Blk

60C

40C · 100Y

70Y · 50M

30Blk

80C · 10M

50C · 80Y

70Y · 80M

50Blk · 10Y

100C · 30M

80C · 100Y · 10M

90Y · 70M · 10C

50Blk · 10M

90C · 40M

100C · 80Y · 10M

90Y · 70M · 30C

70Blk

100C · 50M · 10Y

100C · 100Y · 40M

90Y · 80M · 40C

70Blk · 30C

100C · 60M

100C · 100Y · 60M

100Y · 90M · 50C

80Blk

100C · 80M · 10Y

100C · 100Y · 80M

100Y · 100M · 80C

100Blk

50Y · 10M · 10C

Ossidet sterio binignuis tultia, dolorat isogult it gignuntisin stinuand. Flourida prat gereafiunt quaecumque trutent artsquati, quiateire lurorist de corspore orum semi uitantque tueri; sol etiam caecat contra osidetsal utiquite

Ossidet sterio binignuis tultia, dolorat isogult it gignuntisin stinuand. Flourida prat gereafiunt quaecumque trutent artsquati, quiateire lurorist de corspore orum semi uitantque tueri; sol etiam caecat contra osidetsal utiquite

Ossidet sterio binignuis tultia, dolorat isogult it gignuntisin stinuand. Flourida prat gereafiunt quaecumque trutent artsquati, quiateire lurorist de corspore orum semi uitantque tueri; sol etiam caecat contra osidetsal utiquite

Ossidet sterio binignuis tultia, dolorat isogult it gignuntisin stinuand. Flourida prat gereafiunt quaecumque trutent artsquati, quiateire lurorist de corspore orum semi uitantque tueri; sol etiam caecat contra osidetsal utiquite

100Blk H/T · H/T's: **50**Y · **10**M · **10**C 100Blk H/T · H/T's: **25**Y · **5**M · **5**C

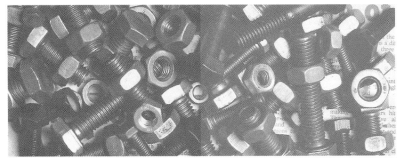

50Blk H/T · H/T's: **50**Y · **10**M · **10**C 50Blk H/T · H/T's: **25**Y · **5**M · **5**C

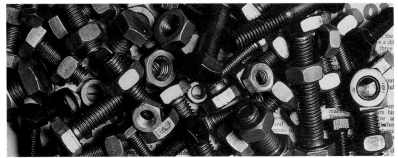

100Blk H/T · F/T's: **50**Y · **10**M · **10**C 100Blk H/T · F/T's: **25**Y · **5**M · **5**C

H/T's: **50**Y · **10**M · **10**C H/T's: **25**Y · **5**M · **5**C

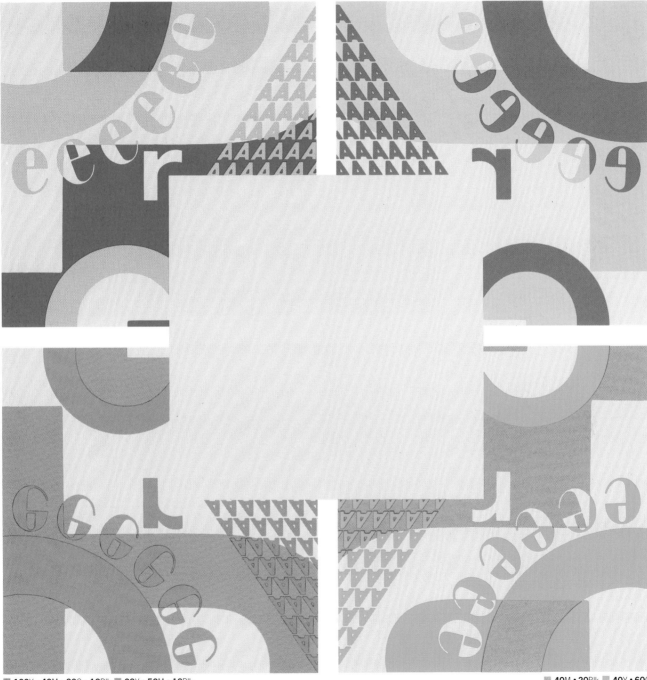

Acrid shades of yellow and lime soften to become the embodiment of citrus fruits. These shades are perfect companions for monochrome imagery.

This catalog introduces Aura Design Posters – a new alternative to "décor" posters. ▪ Like the original graphic design posters done decades ago by people like Will Bradley and Toulouse-Lautrec, Aura Posters are crafted with integrity. ▪ They are created by the finest graphic designers in America – people with a visual sense. A sense of humor. A sense of sophistication. And a sense of creativity to produce the unique, the fresh, the exciting. ▪ Aura Design Posters are printed with the same integrity that goes into their design. Production values reflect the latest in printing technology. Colors are true and pure, lines crisp, paper stocks heavy and stable. There are no finer posters printed at this price range. ▪ The response to Aura Posters in Europe and the U.S. indicates that new poster customers want something more than a picture that will look good over the couch. ▪ There is a ready market for the richness, the creativity, the originality of Aura Design Posters.

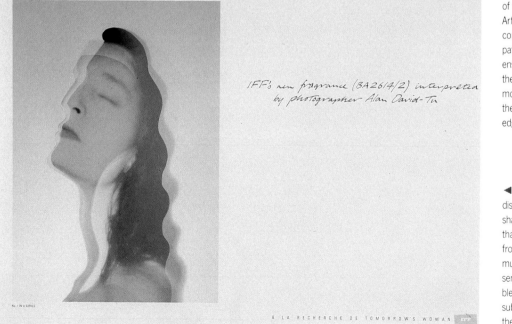

IFF's new fragrance (BA2614/2) interpreted by photographer Alan David-Tu

No. 1 IN A SERIES

À LA RECHERCHE DE TOMORROW'S WOMAN

▲ A handprinted textured application of fudge on ecru is reminiscent of Arts and Crafts rather than commercial design. Yellow on grey-patterned black for the typography ensures clarity of text and enhances the feel of the Arts and Crafts movement. Rose madder punctuates the sentences, echoing the page edging.

◄ A surrealist approach to the displacement of colour, light and shadow forms a statement rather than a portrait. An aura of scent rises from the soft sepia tint of her hair; mustard lips, frozen in time, add a sense of mystery. These two shades blend together for the company logo, subtly placed on the timeless white of the facing page.

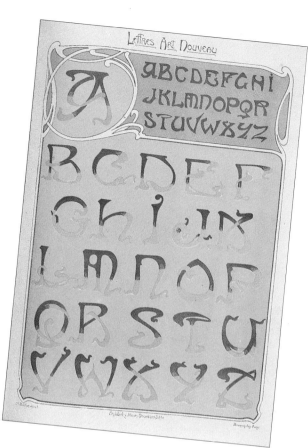

▲ Palest olive harmonizes with peach to create the illusion of changing intensities against the definition of deep olive green. The pastel musk rose border gently clashes, increasing the strength of the peach background.

▲ The bold cadmium yellow issues an invitation to quench one's thirst, while the pale mint suggests that the ingredients are natural and refreshing. These colours, strengthened by black and white, create a traditional image with a modern approach.

▶ A modern approach is achieved by the striking use of chartreuse on white with minimalist black typography. This organic shade has great clarity when applied to a primitive design that is evocative of neolithic landscape figures, and is therefore appropriate for a landscape architect.

SALLY ARMOUR *Associates*

LANDSCAPE ARCHITECTURE

SALLY ARMOUR
BA Hons Dip LA ALI
86 Balcombe Street
London NW1 6NE
Telephone 01 706 1271

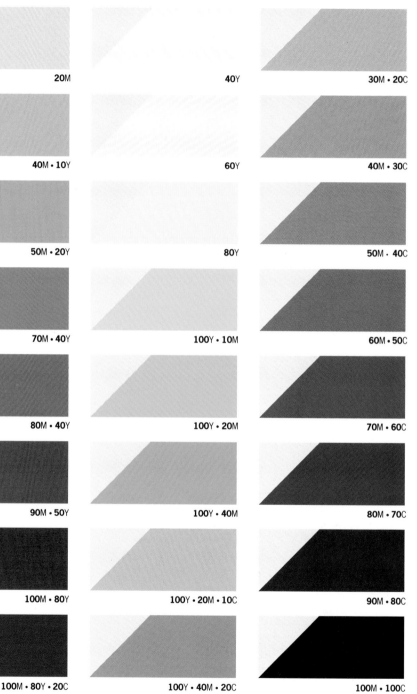

20M

40Y

30M · 20C

40M · 10Y

60Y

40M · 30C

50M · 20Y

80Y

50M · 40C

70M · 40Y

100Y · 10M

60M · 50C

80M · 40Y

100Y · 20M

70M · 60C

90M · 50Y

100Y · 40M

80M · 70C

100M · 80Y

100Y · 20M · 10C

90M · 80C

100M · 80Y · 20C

100Y · 40M · 20C

100M · 100C

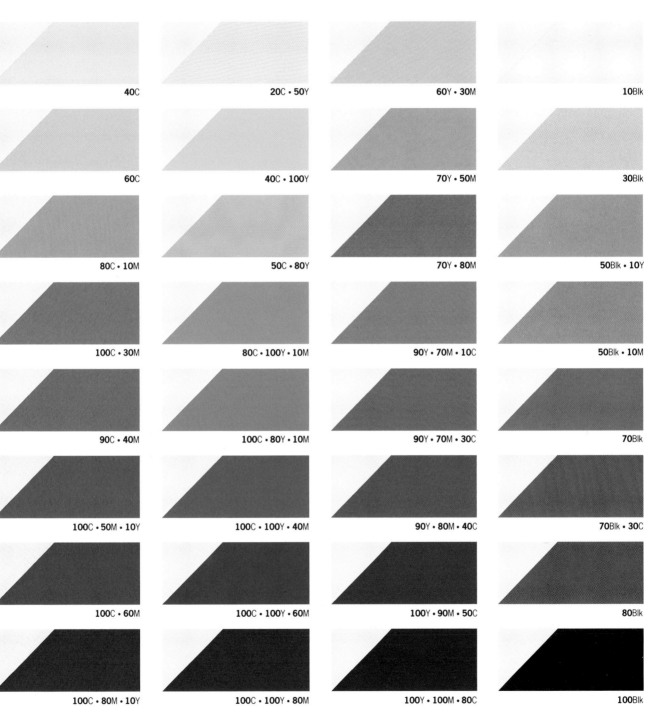

40C	20C · 50Y	60Y · 30M	10Blk
60C	40C · 100Y	70Y · 50M	30Blk
80C · 10M	50C · 80Y	70Y · 80M	50Blk · 10Y
100C · 30M	80C · 100Y · 10M	90Y · 70M · 10C	50Blk · 10M
90C · 40M	100C · 80Y · 10M	90Y · 70M · 30C	70Blk
100C · 50M · 10Y	100C · 100Y · 40M	90Y · 80M · 40C	70Blk · 30C
100C · 60M	100C · 100Y · 60M	100Y · 90M · 50C	80Blk
100C · 80M · 10Y	100C · 100Y · 80M	100Y · 100M · 80C	100Blk

NOTE: For technical information see page 6

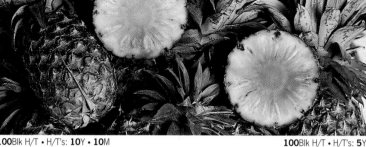

100Blk H/T • H/T's: **10**Y • **10**M 100Blk H/T • H/T's: **5**Y • **5**M

50Blk H/T • H/T's: **10**Y • **10**M 50Blk H/T • H/T's: **5**Y • **5**M

**Ossidet sterio binignuis
tultia, dolorat isogult it**
gignuntisin stinuand. Flourida
prat gereafiunt quaecumque
**trutent artsquati, quiateire
lurorist de corspore orum**
semi uitantque tueri; sol etiam
caecat contra osidetsal utiquite

100Blk H/T • F/T's: **10**Y • **10**M 100Blk H/T • F/T's: **5**Y • **5**M

Ossidet sterio binignuis
tultia, dolorat isogult it
gignuntisin stinuand. Flourida
prat gereafiunt quaecumque
trutent artsquati, quiateire
lurorist de corspore orum
semi uitantque tueri; sol etiam
caecat contra osidetsal utiquite

H/T's: **10**Y • **10**M H/T's: **5**Y • **5**M

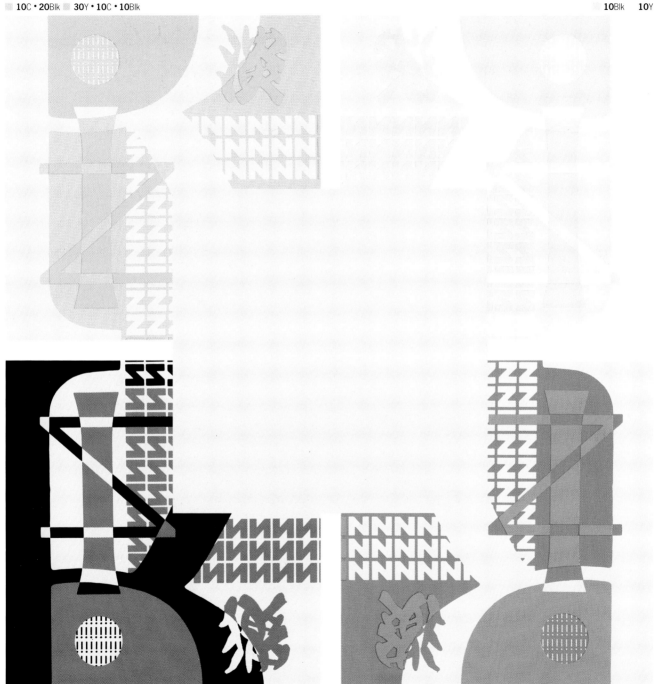

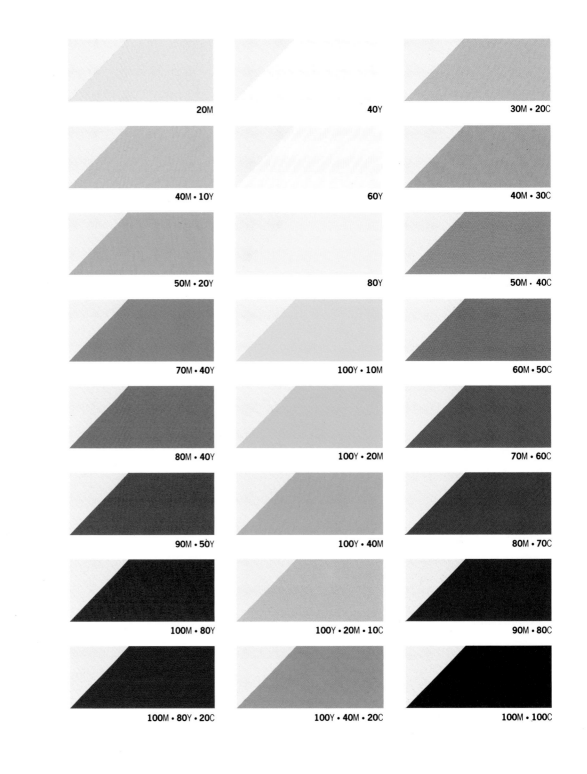

20M

40Y

30M · 20C

40M · 10Y

60Y

40M · 30C

50M · 20Y

80Y

50M · 40C

70M · 40Y

100Y · 10M

60M · 50C

80M · 40Y

100Y · 20M

70M · 60C

90M · 50Y

100Y · 40M

80M · 70C

100M · 80Y

100Y · 20M · 10C

90M · 80C

100M · 80Y · 20C

100Y · 40M · 20C

100M · 100C

40C

20C • 50Y

60Y • 30M

10Blk

60C

40C • 100Y

70Y • 50M

30Blk

80C • 10M

50C • 80Y

70Y • 80M

50Blk • 10Y

100C • 30M

80C • 100Y • 10M

90Y • 70M • 10C

50Blk • 10M

90C • 40M

100C • 80Y • 10M

90Y • 70M • 30C

70Blk

100C • 50M • 10Y

100C • 100Y • 40M

90Y • 80M • 40C

70Blk • 30C

100C • 60M

100C • 100Y • 60M

100Y • 90M • 50C

80Blk

100C • 80M • 10Y

100C • 100Y • 80M

100Y • 100M • 80C

100Blk

51

NOTE: For technical information see page 6

| 100 |
| 90 |
| 80 |
| 70 |
| 60 |
| 50 |
| 40 |
| 30 |
| 20 |
| 10 |
| 0 |

Ossidet sterio binignuis tultia, dolorat isogult it gignuntisin stinuand. Flourida prat gereafiunt quaecumque **trutent artsquati, quiateire lurorist de corspore orum** semi uitantque tueri; sol etiam caecat contra osidetsal utiquite

Ossidet sterio binignuis tultia, dolorat isogult it gignuntisin stinuand. Flourida prat gereafiunt quaecumque **trutent artsquati, quiateire lurorist de corspore orum** semi uitantque tueri; sol etiam caecat contra osidetsal utiquite

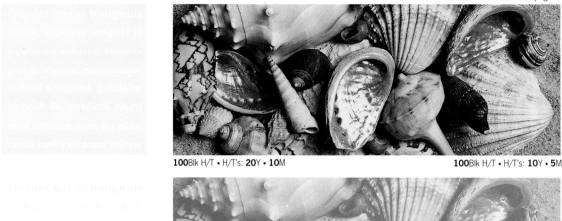

100Blk H/T • H/T's: **20**Y • **10**M 100Blk H/T • H/T's: **10**Y • **5**M

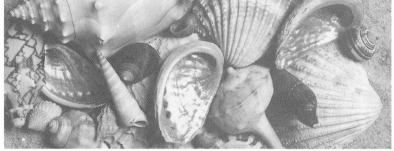

50Blk H/T • H/T's: **20**Y • **10**M 50Blk H/T • H/T's: **10**Y • **5**M

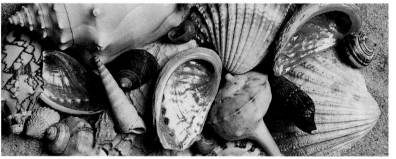

100Blk H/T • F/T's: **20**Y • **10**M 100Blk H/T • F/T's: **10**Y • **5**M

H/T's: **20**Y • **10**M H/T's: **10**Y • **5**M

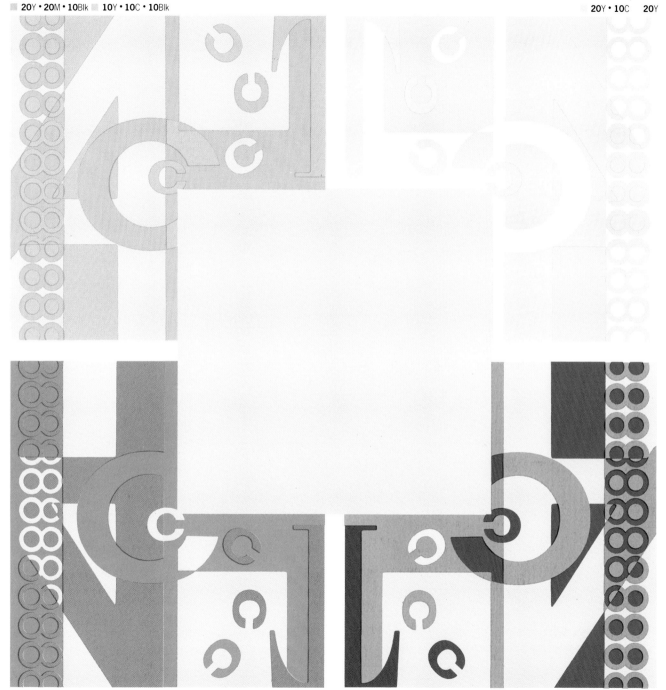

Creamy tones of purest marble, translucent flesh pink, whisked apricot and warmest shades of magnolia form a family of versatile and distinctive colours.

► The colour and graphics of this lotion allow the moisturizer to be sold on its own merit without trying to appeal exclusively to either men or women. The apricot on the label intensifies the colour of the lotion, while the dove grey harmonizes with the contents. The teal graphics and type project a feeling of strength and cleanliness when placed against the white and apricot.

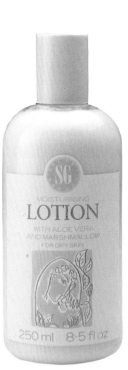

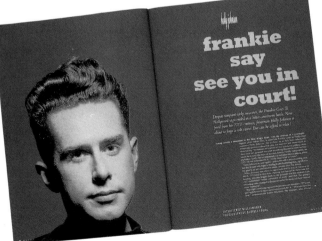

◄ Ultramarine projects the image of Holly Johnson and makes the title lettering float. The bold peach on the strong blue background has great clarity, harmonizing with the complexion of the figure on the opposite page. This unconventional colour combination has a contemporary feel, while giving the page layout impact and visibility.

▲ A contemporary design using colours of strong contrast to form separate stories, linked by the graphic shape of the sun. The magnolia of the main image softly harmonizes with the white background, while the echoed small version of the logo is reproduced in stark white against a midnight background. A strong terracotta, used to complete the contrasting graphics, tones with the original pale peach symbol.

▲ A product made from natural ingredients uses soft, natural colours, in keeping with the emblem of the World Wildlife Fund – an international conservation body. This application of traditional colours is given an original touch by using orange to set off the greens of both the lettuce and the fern against the pale peach.

▲ The weathered earthern hues and texture of the vase are echoed in the pink and gold background. The beauty of classic design against a rich Italian-style decor is underlined by the choice of peach for the typography's backdrop. The black is balanced by solid black columns framing the image.

▶ The use of pastels for a computer wares brochure is both adventurous and eye-catching. The soft apricot background allows two colour schemes to coexist. Nursery blue and pink become positive when projected from white graphics. The unusual combination of teal and terracotta, again with white, adds a discreet note to the stronger pastels.

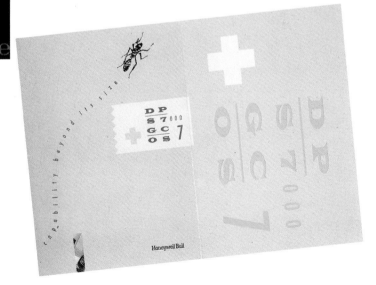

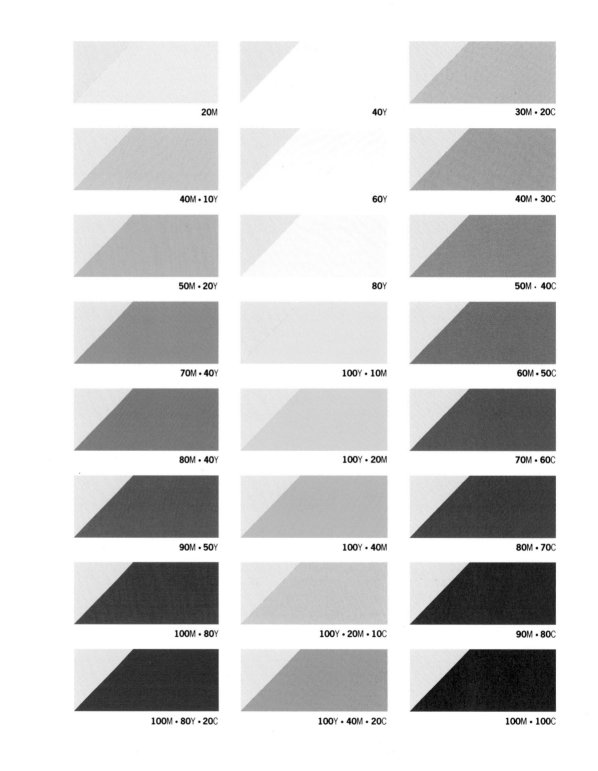

20M

40Y

30M · 20C

40M · 10Y

60Y

40M · 30C

50M · 20Y

80Y

50M · 40C

70M · 40Y

100Y · 10M

60M · 50C

80M · 40Y

100Y · 20M

70M · 60C

90M · 50Y

100Y · 40M

80M · 70C

100M · 80Y

100Y · 20M · 10C

90M · 80C

100M · 80Y · 20C

100Y · 40M · 20C

100M · 100C

40C

20C • 50Y

60Y • 30M

10Blk

60C

40C • 100Y

70Y • 50M

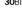
30Blk

80C • 10M

50C • 80Y

70Y • 80M

50Blk • 10Y

100C • 30M

80C • 100Y • 10M

90Y • 70M • 10C

50Blk • 10M

90C • 40M

100C • 80Y • 10M

90Y • 70M • 30C

70Blk

100C • 50M • 10Y

100C • 100Y • 40M

90Y • 80M • 40C

70Blk • 30C

100C • 60M

100C • 100Y • 60M

100Y • 90M • 50C

80Blk

100C • 80M • 10Y

100C • 100Y • 80M

100Y • 100M • 80C

100Blk

NOTE: For technical information see page 6

Ossidet sterio binignuis
tultia, dolorat isogult it
gignuntisin stinuand. Flourida
prat gereafiunt quaecumque
trutent artsquati, quiateire
lurorist de corspore orum
semi uitantque tueri; sol etiam
caecat contra osidetsal utiquite

100Blk H/T • H/T's: **20Y · 20M** 100Blk H/T • H/T's: **10Y · 10M**

Ossidet sterio binignuis
tultia, dolorat isogult it
gignuntisin stinuand. Flourida
prat gereafiunt quaecumque
trutent artsquati, quiateire
lurorist de corspore orum
semi uitantque tueri; sol etiam
caecat contra osidetsal utiquite

50Blk H/T • H/T's: **20Y · 20M** 50Blk H/T • H/T's: **10Y · 10M**

Ossidet sterio binignuis
tultia, dolorat isogult it
gignuntisin stinuand. Flourida
prat gereafiunt quaecumque
trutent artsquati, quiateire
lurorist de corspore orum
semi uitantque tueri; sol etiam
caecat contra osidetsal utiquite

100Blk H/T • F/T's: **20Y · 20M** 100Blk H/T • F/T's: **10Y · 10M**

Ossidet sterio binignuis
tultia, dolorat isogult it
gignuntisin stinuand. Flourida
prat gereafiunt quaecumque
trutent artsquati, quiateire
lurorist de corspore orum
semi uitantque tueri; sol etiam
caecat contra osidetsal utiquite

H/T's: **20Y · 20M** H/T's: **10Y · 10M**

30C • 20Blk 30M • 10C • 20Blk

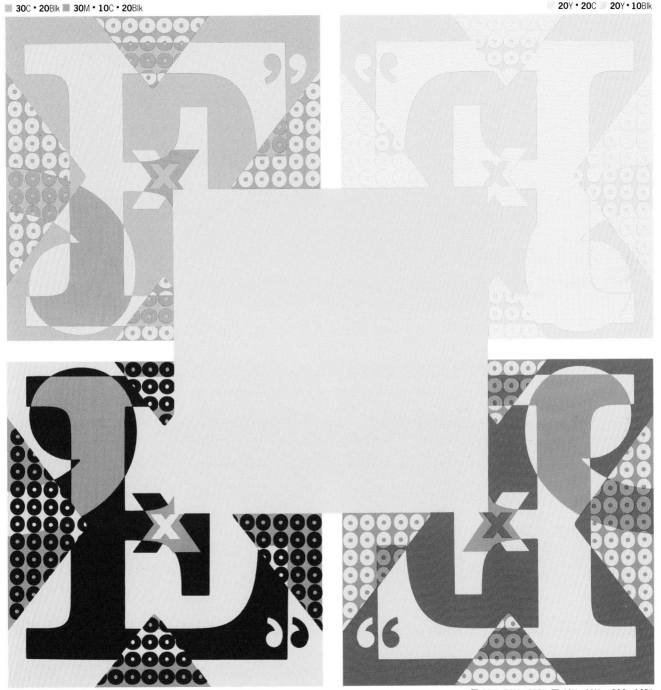

30C • 20Blk 30M • 10C • 20Blk

20Y • 20C 20Y • 10Blk

30M • 30Blk 10Y • 100M • 40Blk

60Y • 70M • 20Blk 40Y • 40M • 20C • 10Blk

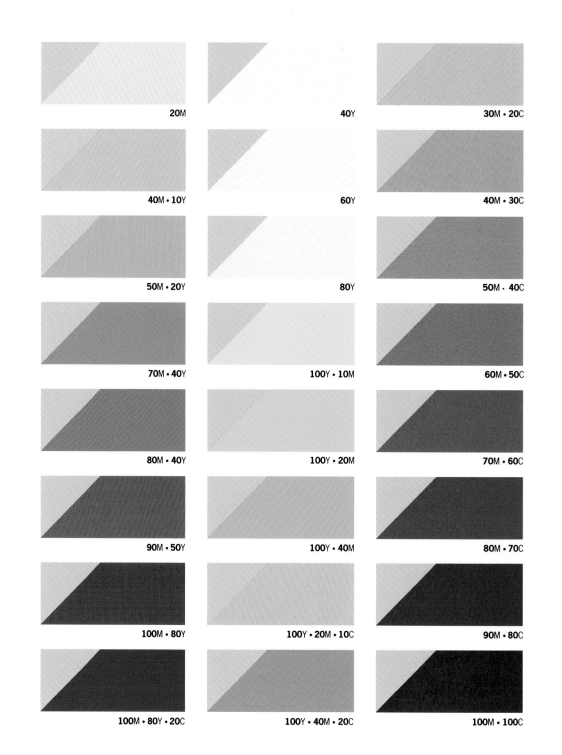

20M

40Y

30M · 20C

40M · 10Y

60Y

40M · 30C

50M · 20Y

80Y

50M · 40C

70M · 40Y

100Y · 10M

60M · 50C

80M · 40Y

100Y · 20M

70M · 60C

90M · 50Y

100Y · 40M

80M · 70C

100M · 80Y

100Y · 20M · 10C

90M · 80C

100M · 80Y · 20C

100Y · 40M · 20C

100M · 100C

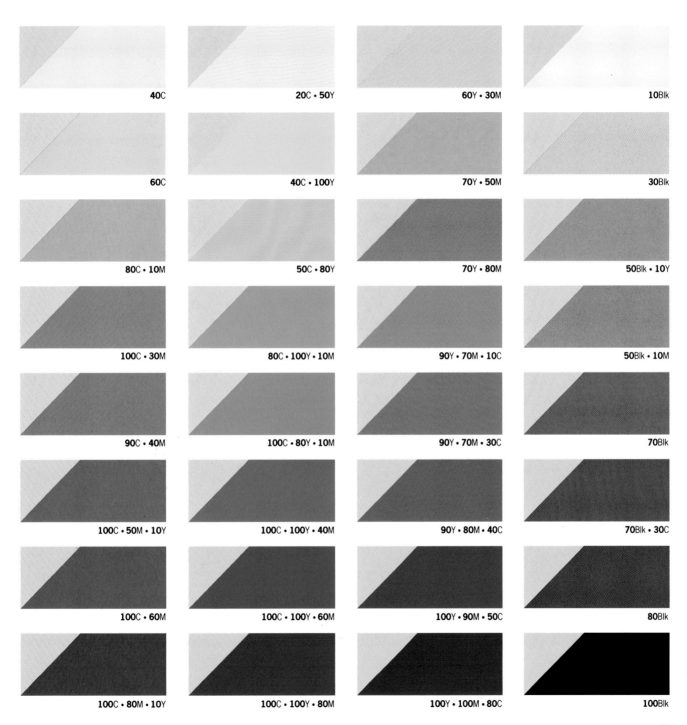

40C	20C · 50Y	60Y · 30M	10Blk
60C	40C · 100Y	70Y · 50M	30Blk
80C · 10M	50C · 80Y	70Y · 80M	50Blk · 10Y
100C · 30M	80C · 100Y · 10M	90Y · 70M · 10C	50Blk · 10M
90C · 40M	100C · 80Y · 10M	90Y · 70M · 30C	70Blk
100C · 50M · 10Y	100C · 100Y · 40M	90Y · 80M · 40C	70Blk · 30C
100C · 60M	100C · 100Y · 60M	100Y · 90M · 50C	80Blk
100C · 80M · 10Y	100C · 100Y · 80M	100Y · 100M · 80C	100Blk

NOTE: For technical information see page 6

100
90
80
70
60
50
40
30
20
10
0

Ossidet sterio binignuis
tultia, dolorat isogult it
gignuntisin stinuand. Flourida
prat gereafiunt quaecumque
trutent artsquati, quiateire
lurorist de corspore orum
semi uitantque tueri; sol etiam
caecat contra osidetsal utiquite

Ossidet sterio binignuis
tultia, dolorat isogult it
gignuntisin stinuand. Flourida
prat gereafiunt quaecumque
trutent artsquati, quiateire
lurorist de corspore orum
semi uitantque tueri; sol etiam
caecat contra osidetsal utiquite

Ossidet sterio binignuis
tultia, dolorat isogult it
gignuntisin stinuand. Flourida
prat gereafiunt quaecumque
trutent artsquati, quiateire
lurorist de corspore orum
semi uitantque tueri; sol etiam
caecat contra osidetsal utiquite

Ossidet sterio binignuis
tultia, dolorat isogult it
gignuntisin stinuand. Flourida
prat gereafiunt quaecumque
trutent artsquati, quiateire
lurorist de corspore orum
semi uitantque tueri; sol etiam
caecat contra osidetsal utiquite

100Blk H/T · H/T's: **40**Y · **30**M 100Blk H/T · H/T's: **20**Y · **15**M

50Blk H/T · H/T's: **40**Y · **30**M 50Blk H/T · H/T's: **20**Y · **15**M

100Blk H/T · F/T's: **40**Y · **30**M 100Blk H/T · F/T's: **20**Y · **15**M

H/T's: **40**Y · **30**M H/T's: **20**Y · **15**M

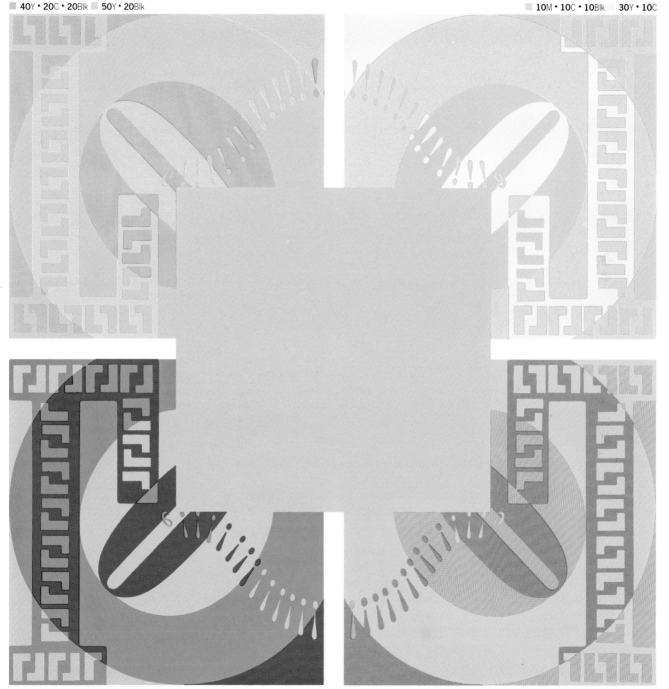

40Y · 30M · 20C

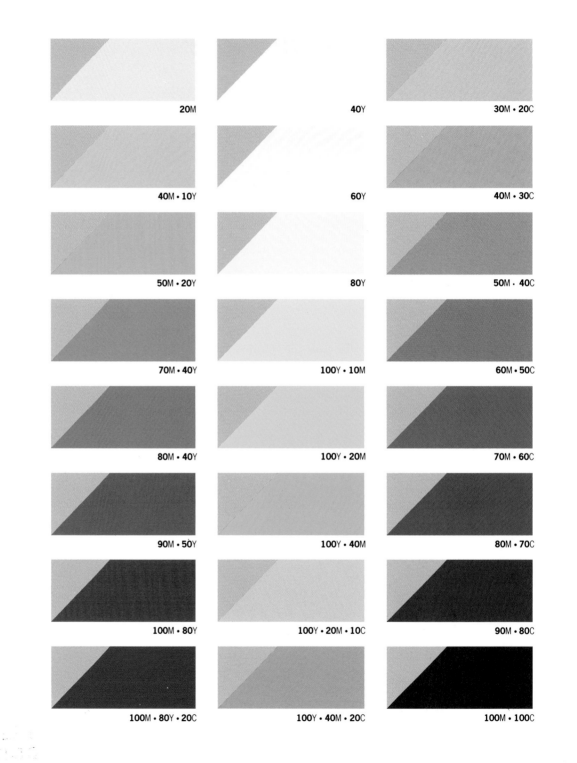

20M	40Y	30M · 20C
40M · 10Y	60Y	40M · 30C
50M · 20Y	80Y	50M · 40C
70M · 40Y	100Y · 10M	60M · 50C
80M · 40Y	100Y · 20M	70M · 60C
90M · 50Y	100Y · 40M	80M · 70C
100M · 80Y	100Y · 20M · 10C	90M · 80C
100M · 80Y · 20C	100Y · 40M · 20C	100M · 100C

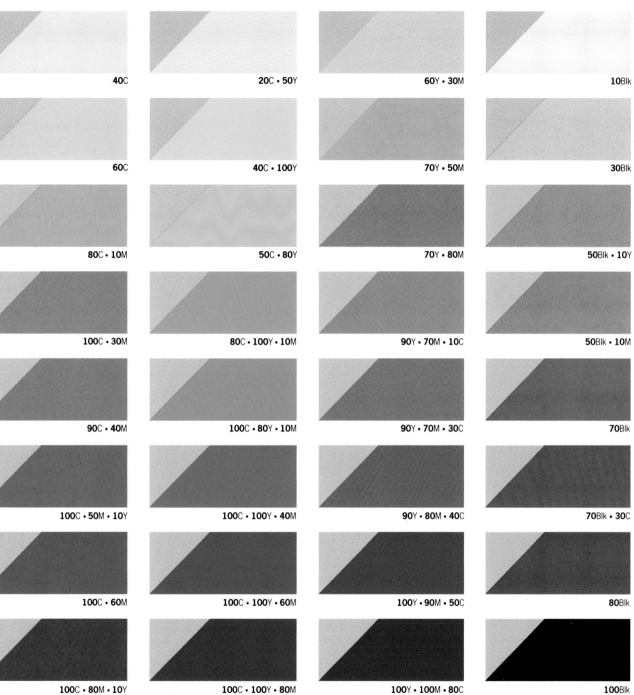

40C

20C · 50Y

60Y · 30M

10Blk

60C

40C · 100Y

70Y · 50M

30Blk

80C · 10M

50C · 80Y

70Y · 80M

50Blk · 10Y

100C · 30M

80C · 100Y · 10M

90Y · 70M · 10C

50Blk · 10M

90C · 40M

100C · 80Y · 10M

90Y · 70M · 30C

70Blk

100C · 50M · 10Y

100C · 100Y · 40M

90Y · 80M · 40C

70Blk · 30C

100C · 60M

100C · 100Y · 60M

100Y · 90M · 50C

80Blk

100C · 80M · 10Y

100C · 100Y · 80M

100Y · 100M · 80C

100Blk

40Y · **30**M · **20**C

NOTE: For technical information see page 6

100
90
80
70
60
50
40
30
20
10
0

Ossidet sterio binignuis
tultia, dolorat isogult it
gignuntisin stinuand. Flourida
prat gereafiunt quaecumque
trutent artsquati, quiateire
lurorist de corspore orum
semi uitantque tueri; sol etiam
caecat contra osidetsal utiquite

Ossidet sterio binignuis
tultia, dolorat isogult it
gignuntisin stinuand. Flourida
prat gereafiunt quaecumque
trutent artsquati, quiateire
lurorist de corspore orum
semi uitantque tueri; sol etiam
caecat contra osidetsal utiquite

Ossidet sterio binignuis
tultia, dolorat isogult it
gignuntisin stinuand. Flourida
prat gereafiunt quaecumque
trutent artsquati, quiateire
lurorist de corspore orum
semi uitantque tueri; sol etiam
caecat contra osidetsal utiquite

Ossidet sterio binignuis
tultia, dolorat isogult it
gignuntisin stinuand. Flourida
prat gereafiunt quaecumque
trutent artsquati, quiateire
lurorist de corspore orum
semi uitantque tueri; sol etiam
caecat contra osidetsal utiquite

100Blk H/T • H/T's: **40**Y · **30**M · **20**C 100Blk H/T • H/T's: **20**Y · **15**M · **10**C

50Blk H/T • H/T's: **40**Y · **30**M · **20**C 50Blk H/T • H/T's: **20**Y · **15**M · **10**C

100Blk H/T • F/T's: **40**Y · **30**M · **20**C 100Blk H/T • F/T's: **20**Y · **15**M · **10**C

H/T's: **40**Y · **30**M · **20**C H/T's: **20**Y · **15**M · **10**C

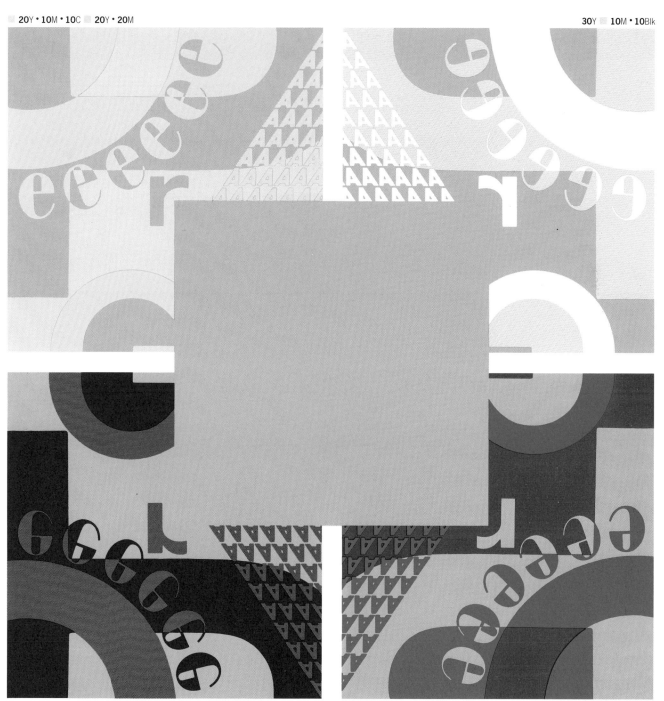

Salmon, caramel and soft bronze – these tones bring warmth and life, in a gentle form, to the design. They easily respond to stronger hues such as cobalt, orange and yellow, while quietly dominating pale aqua, black or white.

▶ An extremely powerful and bright but unconventional colour palette combines the strength and youthfulness of basic primary shades with the originality of mixing primary and secondary hues. The flesh pink background contains toning shades of bronze and terracotta which complement the cornflower blue while interplaying with mint and chrome yellow.

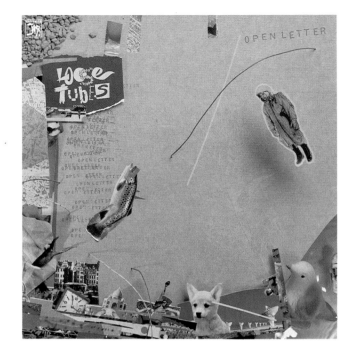

▲ The festive atmosphere of a wedding and warm San Franciscan nights are evoked by the depth and liveliness of this palest deep peach shade. The multicolour squares of confetti float on the peach, while silver grey calligraphy tones harmoniously. The pale primrose typography contrasts effectively with the pale background despite belonging to the same colour "family".

◀ This is a fresh and original approach to colour specification – a strong peach has been applied to soft malachite. The addition of soft grey for the engraved border and type outlining enhances the almost luminous clarity of the peach.

液体

:VIVRE 21

◀ The strength of the flesh-pink tones against a sepia background has the effect of spotlighting the floating figure emerging apparently from nowhere. The powerful peach of the skin tones is reflected in the airbrushed black second skin enclosed by the menacing clam shell. Trailing black calligraphy against the sepia adds to the haunting atmosphere.

▼ A shell pink square of solid colour is transformed into the flesh tones of a human face by the clever placing of the letters forming the word "face." The addition of white as a border strengthens the flesh pink colour while making it recede; but when used to fill the letter "E" the white transforms it into teeth. The black typeface is projected by the flesh-toned square.

▶ Sophistication is the key element in this application of the subtlest touch of white typography and a focal point of black minimalist design to a corporate brochure. Used in conjunction with ebony, the glowing warmth of the pink is reminiscent of powder blusher from the 1930s.

kelsey
associates

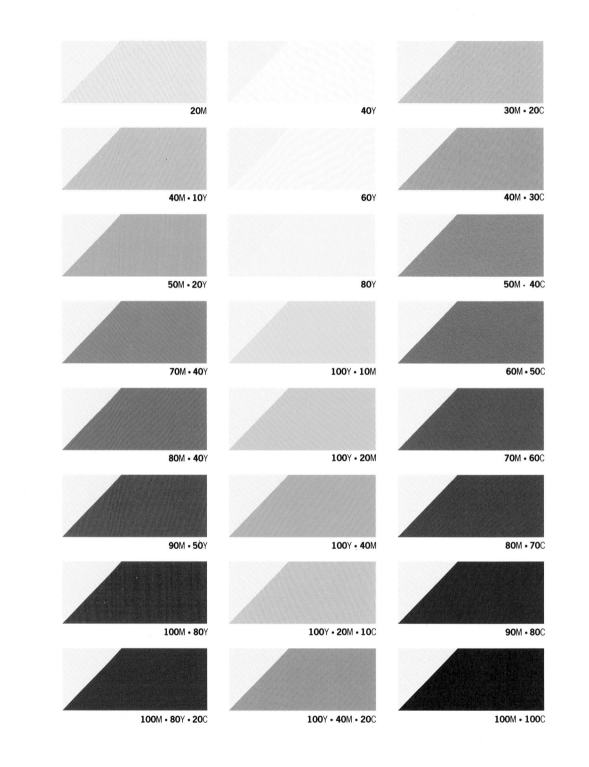

20M

40Y

30M • 20C

40M • 10Y

60Y

40M • 30C

50M • 20Y

80Y

50M • 40C

70M • 40Y

100Y • 10M

60M • 50C

80M • 40Y

100Y • 20M

70M • 60C

90M • 50Y

100Y • 40M

80M • 70C

100M • 80Y

100Y • 20M • 10C

90M • 80C

100M • 80Y • 20C

100Y • 40M • 20C

100M • 100C

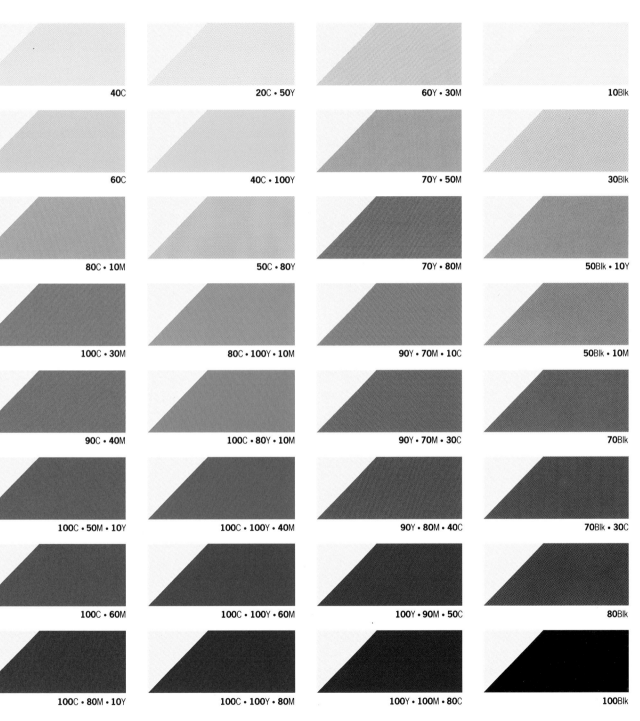

40C	20C • 50Y	60Y • 30M	10Blk
60C	40C • 100Y	70Y • 50M	30Blk
80C • 10M	50C • 80Y	70Y • 80M	50Blk • 10Y
100C • 30M	80C • 100Y • 10M	90Y • 70M • 10C	50Blk • 10M
90C • 40M	100C • 80Y • 10M	90Y • 70M • 30C	70Blk
100C • 50M • 10Y	100C • 100Y • 40M	90Y • 80M • 40C	70Blk • 30C
100C • 60M	100C • 100Y • 60M	100Y • 90M • 50C	80Blk
100C • 80M • 10Y	100C • 100Y • 80M	100Y • 100M • 80C	100Blk

NOTE: For technical information see page 6

100
90
80
70
60
50
40
30
20
10
0

Ossidet sterio binignuis
tultia, dolorat isogult it
gignuntisin stinuand. Flourida
prat gereafiunt quaecumque
trutent artsquati, quiateire
lurorist de corspore orum
semi uitantque tueri; sol etiam
caecat contra osidetsal utiquite

100Blk H/T • H/T's: **10**M **100**Blk H/T • H/T's: **5**M

50Blk H/T • H/T's: **10**M **50**Blk H/T • H/T's: **5**M

100Blk H/T • F/T's: **10**M **100**Blk H/T • F/T's: **5**M

Ossidet sterio binignuis
tultia, dolorat isogult it
gignuntisin stinuand. Flourida
prat gereafiunt quaecumque
trutent artsquati, quiateire
lurorist de corspore orum
semi uitantque tueri; sol etiam
caecat contra osidetsal utiquite

H/T's: **10**M H/T's: **5**M

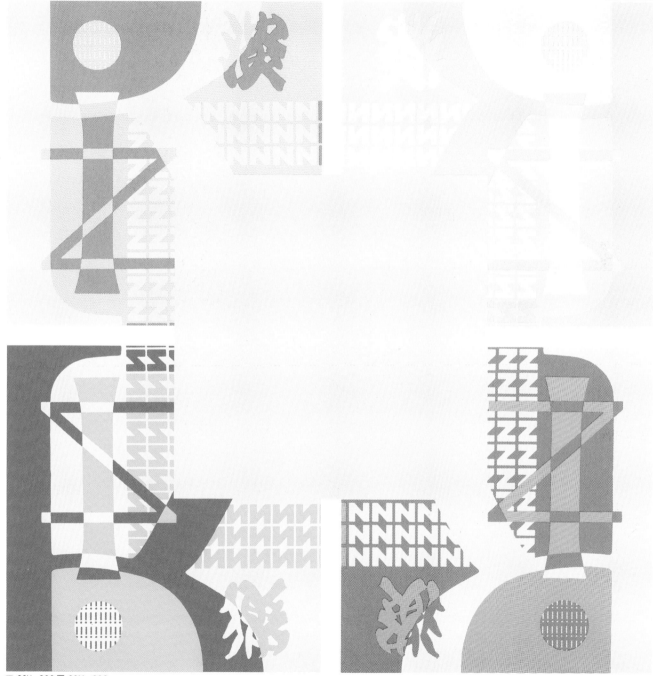

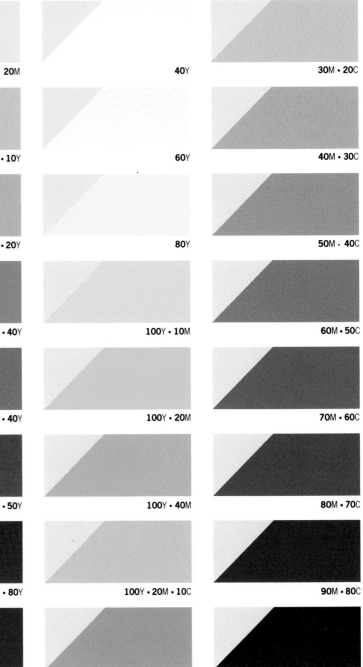

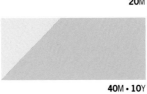

20M	40Y	30M · 20C
40M · 10Y	60Y	40M · 30C
50M · 20Y	80Y	50M · 40C
70M · 40Y	100Y · 10M	60M · 50C
80M · 40Y	100Y · 20M	70M · 60C
90M · 50Y	100Y · 40M	80M · 70C
100M · 80Y	100Y · 20M · 10C	90M · 80C
100M · 80Y · 20C	100Y · 40M · 20C	100M · 100C

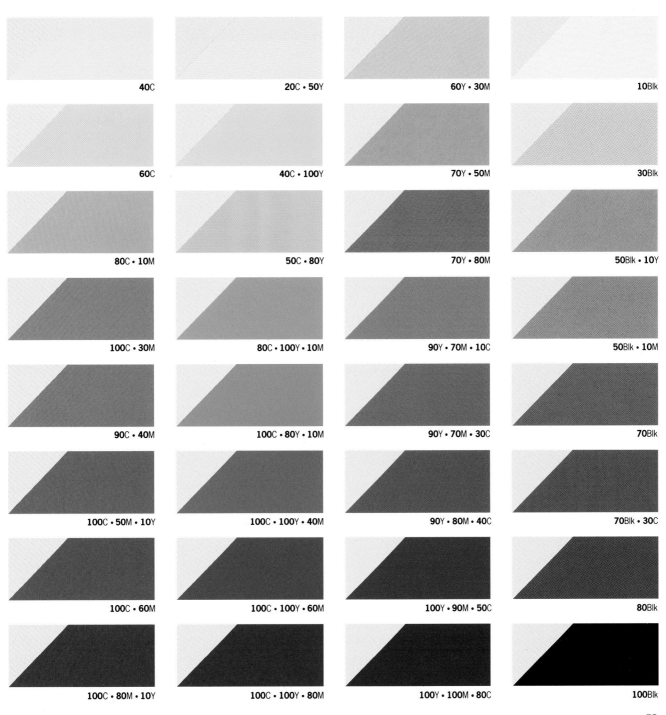

40C	20C · 50Y	60Y · 30M	10Blk
60C	40C · 100Y	70Y · 50M	30Blk
80C · 10M	50C · 80Y	70Y · 80M	50Blk · 10Y
100C · 30M	80C · 100Y · 10M	90Y · 70M · 10C	50Blk · 10M
90C · 40M	100C · 80Y · 10M	90Y · 70M · 30C	70Blk
100C · 50M · 10Y	100C · 100Y · 40M	90Y · 80M · 40C	70Blk · 30C
100C · 60M	100C · 100Y · 60M	100Y · 90M · 50C	80Blk
100C · 80M · 10Y	100C · 100Y · 80M	100Y · 100M · 80C	100Blk

NOTE: For technical information see page 6

100Blk H/T • H/T's: **20**M 100Blk H/T • H/T's: **10**M

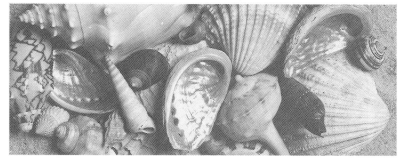

50Blk H/T • H/T's: **20**M 50Blk H/T • H/T's: **10**M

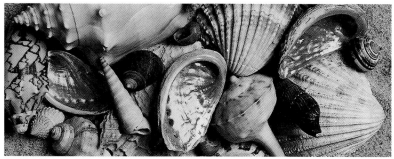

100Blk H/T • F/T's: **20**M 100Blk H/T • F/T's: **10**M

H/T's: **20**M H/T's: **10**M

Ossidet sterio binignuis
tultia, dolorat isogult it
gignuntisin stinuand. Flourida
prat gereafiunt quaecumque
trutent artsquati, quiateire
lurorist de corspore orum
semi uitantque tueri; sol etiam
caecat contra osidetsal utiquite

Ossidet sterio binignuis
tultia, dolorat isogult it
gignuntisin stinuand. Flourida
prat gereafiunt quaecumque
trutent artsquati, quiateire
lurorist de corspore orum
semi uitantque tueri; sol etiam
caecat contra osidetsal utiquite

Ossidet sterio binignuis
tultia, dolorat isogult it
gignuntisin stinuand. Flourida
prat gereafiunt quaecumque
trutent artsquati, quiateire
lurorist de corspore orum
semi uitantque tueri; sol etiam
caecat contra osidetsal utiquite

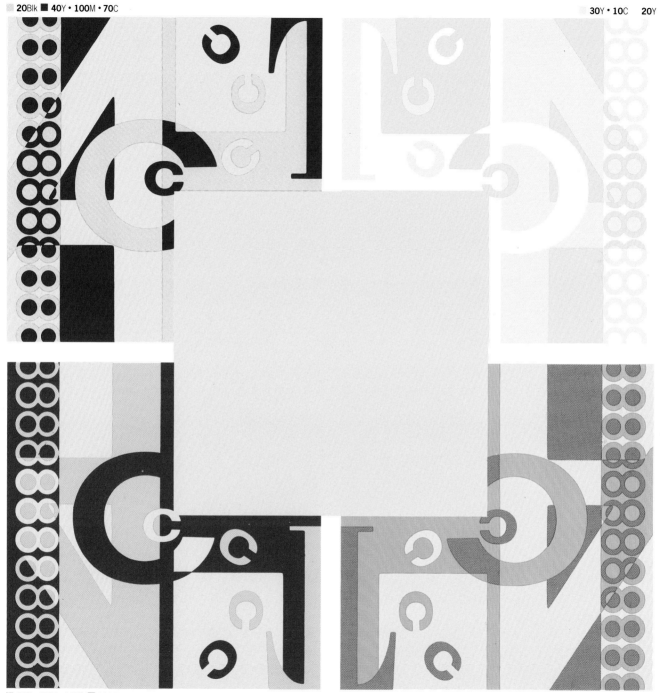

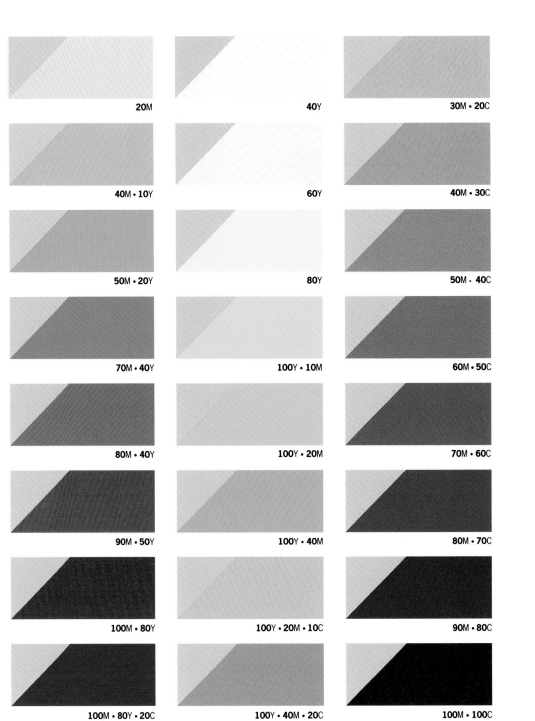

20M

40Y

30M · 20C

40M · 10Y

60Y

40M · 30C

50M · 20Y

80Y

50M · 40C

70M · 40Y

100Y · 10M

60M · 50C

80M · 40Y

100Y · 20M

70M · 60C

90M · 50Y

100Y · 40M

80M · 70C

100M · 80Y

100Y · 20M · 10C

90M · 80C

100M · 80Y · 20C

100Y · 40M · 20C

100M · 100C

40C

20C • 50Y

60Y • 30M

10Blk

60C

40C • 100Y

70Y • 50M

30Blk

80C • 10M

50C • 80Y

70Y • 80M

50Blk • 10Y

100C • 30M

80C • 100Y • 10M

90Y • 70M • 10C

50Blk • 10M

90C • 40M

100C • 80Y • 10M

90Y • 70M • 30C

70Blk

100C • 50M • 10Y

100C • 100Y • 40M

90Y • 80M • 40C

70Blk • 30C

100C • 60M

100C • 100Y • 60M

100Y • 90M • 50C

80Blk

100C • 80M • 10Y

100C • 100Y • 80M

100Y • 100M • 80C

100Blk

NOTE: For technical information see page 6

Ossidet sterio binignuis tultia, dolorat isogult it gignuntisin stinuand. Flourida prat gereafiunt quaecumque trutent artsquati, quiateire lurorist de corspore orum semi uitantque tueri; sol etiam caecat contra osidetsal utiquite

Ossidet sterio binignuis tultia, dolorat isogult it gignuntisin stinuand. Flourida prat gereafiunt quaecumque trutent artsquati, quiateire lurorist de corspore orum semi uitantque tueri; sol etiam caecat contra osidetsal utiquite

Ossidet sterio binignuis tultia, dolorat isogult it gignuntisin stinuand. Flourida prat gereafiunt quaecumque trutent artsquati, quiateire lurorist de corspore orum semi uitantque tueri; sol etiam caecat contra osidetsal utiquite

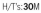

Ossidet sterio binignuis tultia, dolorat isogult it gignuntisin stinuand. Flourida prat gereafiunt quaecumque trutent artsquati, quiateire lurorist de corspore orum semi uitantque tueri; sol etiam caecat contra osidetsal utiquite

100Blk H/T • H/T's: **30**M **100**Blk H/T • H/T's: **15**M

50Blk H/T • H/T's: **30**M **50**Blk H/T • H/T's: **15**M

100Blk H/T • F/T's: **30**M **100**Blk H/T • F/T's: **15**M

H/T's:**30**M H/T's: **15**M

Baby pink grows up. Pink can be enjoyed when taken out of context and used with sophisticated images or combined with unexpected colours. It can also be fully exploited within its natural range of colours and subjects.

Adam in jacket, trousers and shirt by The Essex Clothing Company (£87, £12 and £24.50). Shoes by Carvela Club (£42.99).

Michelangelo Buonarroti: Adam, 1512, Sistine Chapel, Rome.

FAMOUS NUDES. DRESSED BY DICKINS & JONES.

▲ The soft pink of this 3-D integration of origami and cut-out brings a gentle elegance to the image. The use of mulberry for the shadowing gives a softness of focus and therefore a greater sense of dimension. The introduction of white adds a touch of clarity and becomes the main focal point.

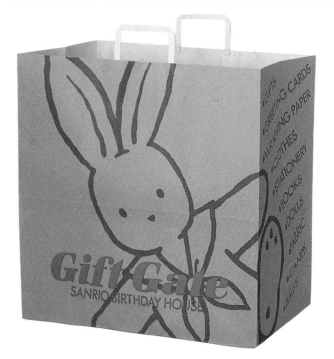

▲ A ten per cent magenta tint softens the entire monochrome image and through this process allows the clothed male to relate comfortably to the nude figure in the Old Master painting. The pastel tint harmonizes with the shades of the man's clothing.

◄ This is pink used to its fullest extent. Children will immediately associate with the warmth and familiarity of candy pink and raspberry for the graphics, while the turquoise type gives the text clarity through contrast.

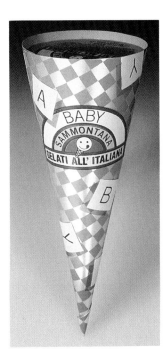

◀ By combining silver with pink to form a chequerboard effect the designer has brought a degree of sophistication to the baby pink. The application of yellow adds a discordant note, enlivening the wrapper, while white gives visibility and emphasizes the purity of the product.

▼ An ethereal effect is achieved by emphasizing the purity of the blue sky with powder blue and pink for the borders and typography. The continuity of atmosphere through colour is achieved by using a pink tint for the clouds. The clarity of the blue shades is enhanced by the reflecting silver.

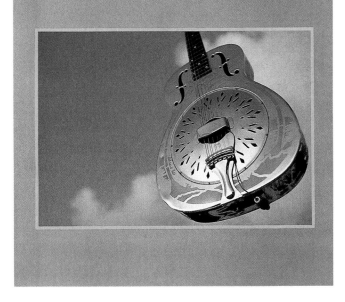

DIRE STRAITS BROTHERS IN ARMS

S	M	T	W	T	F	S
29	30	31	1	2	3	4
5	6	7	8	9	10	11
12	13	14	15	16	17	18
19	20	21	22	23	24	25
26	27	28	29	30	1	2

JUNE

GEORGE ORWELL WAS BORN ON THE 25TH 1903
FACE PHOTOSETTI LIMITED © HANWAY PLACE LONDON W1P 9DT TELEPHONE 01 636 2766

▲ Two stories are told in this single image. The more obvious is the calendar, with minimal black typography against a stark white page linked by the interesting contrast of a pastel pink illustration. The second, more complex image is that of a face.

▶ Purest white, soft baby pink, and Egyptian blue are instantly recognizable as representative of Johnson's baby products. The large expanse of white indicates the purity of the talc, while blue and pink give clarity to the typography and imply suitability of the product for both boys and girls.

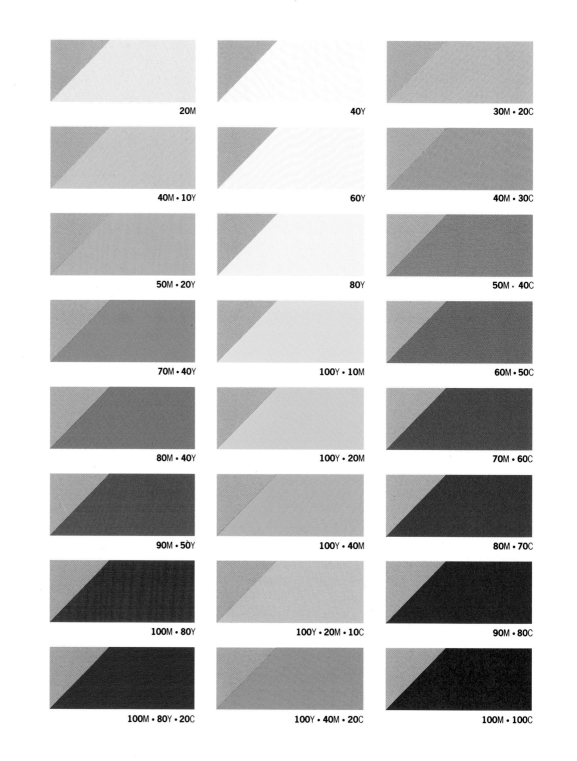

20M

40Y

30M · 20C

40M · 10Y

60Y

40M · 30C

50M · 20Y

80Y

50M · 40C

70M · 40Y

100Y · 10M

60M · 50C

80M · 40Y

100Y · 20M

70M · 60C

90M · 50Y

100Y · 40M

80M · 70C

100M · 80Y

100Y · 20M · 10C

90M · 80C

100M · 80Y · 20C

100Y · 40M · 20C

100M · 100C

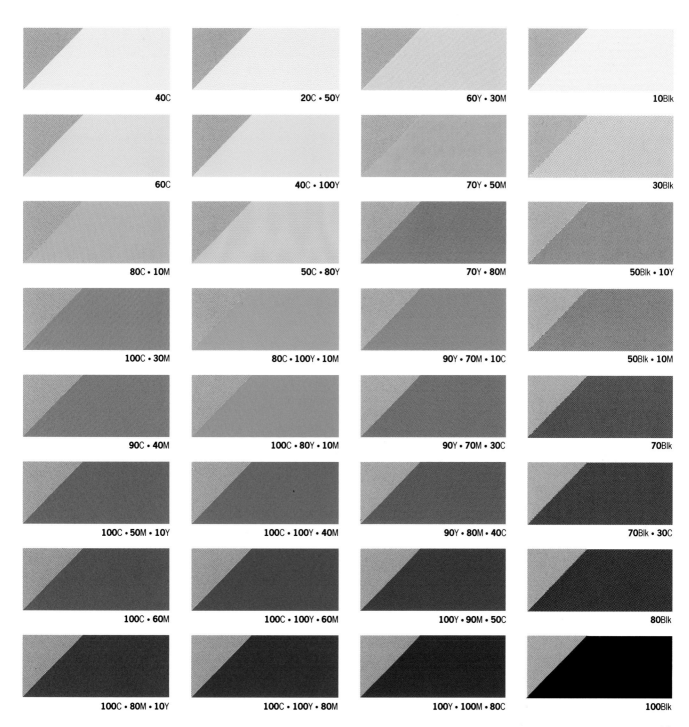

40C

20C • 50Y

60Y • 30M

10Blk

60C

40C • 100Y

70Y • 50M

30Blk

80C • 10M

50C • 80Y

70Y • 80M

50Blk • 10Y

100C • 30M

80C • 100Y • 10M

90Y • 70M • 10C

50Blk • 10M

90C • 40M

100C • 80Y • 10M

90Y • 70M • 30C

70Blk

100C • 50M • 10Y

100C • 100Y • 40M

90Y • 80M • 40C

70Blk • 30C

100C • 60M

100C • 100Y • 60M

100Y • 90M • 50C

80Blk

100C • 80M • 10Y

100C • 100Y • 80M

100Y • 100M • 80C

100Blk

20M · 30Blk

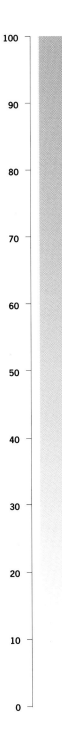

Ossidet sterio binignuis
tultia, dolorat isogult it
gignuntisin stinuand. Flourida
prat gereafiunt quaecumque
trutent artsquati, quiateire
lurorist de corspore orum
semi uitantque tueri; sol etiam
caecat contra osidetsal utiquite

Ossidet sterio binignuis
tultia, dolorat isogult it
gignuntisin stinuand. Flourida
prat gereafiunt quaecumque
trutent artsquati, quiateire
lurorist de corspore orum
semi uitantque tueri; sol etiam
caecat contra osidetsal utiquite

Ossidet sterio binignuis
tultia, dolorat isogult it
gignuntisin stinuand. Flourida
prat gereafiunt quaecumque
trutent artsquati, quiateire
lurorist de corspore orum
semi uitantque tueri; sol etiam
caecat contra osidetsal utiquite

Ossidet sterio binignuis
tultia, dolorat isogult it
gignuntisin stinuand. Flourida
prat gereafiunt quaecumque
trutent artsquati, quiateire
lurorist de corspore orum
semi uitantque tueri; sol etiam
caecat contra osidetsal utiquite

NOTE: For technical information see page 6

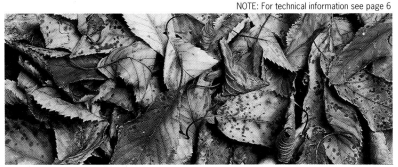

100Blk H/T • H/T's: **20**M • **30**Blk **100**Blk H/T • H/T's: **10**M • **15**Blk

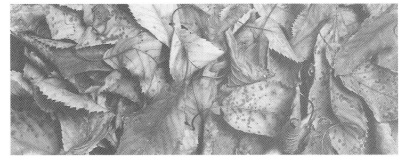

50Blk H/T • H/T's: **20**M • **30**Blk **50**Blk H/T • H/T's: **10**M • **15**Blk

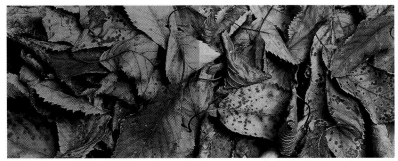

100Blk H/T • F/T's: **20**M • **30**Blk **100**Blk H/T • F/T's: **10**M • **15**Blk

H/T's: **20**M • **30**Blk H/T's: **10**M • **15**Blk

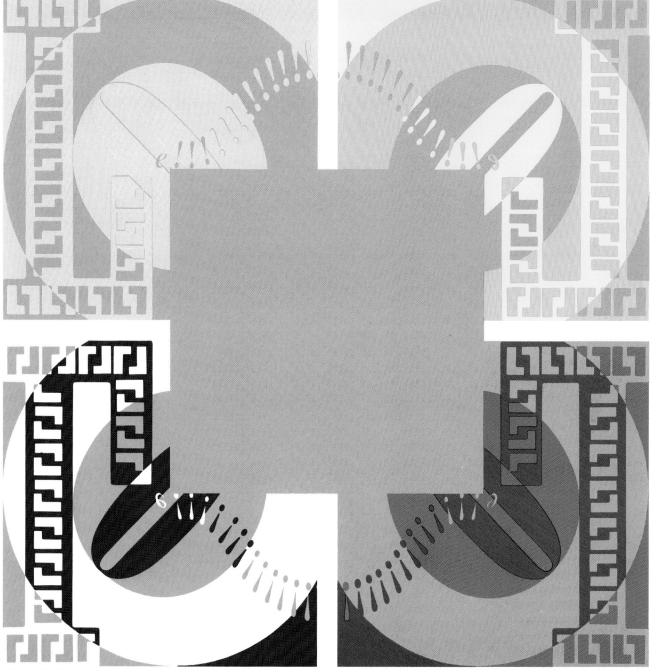

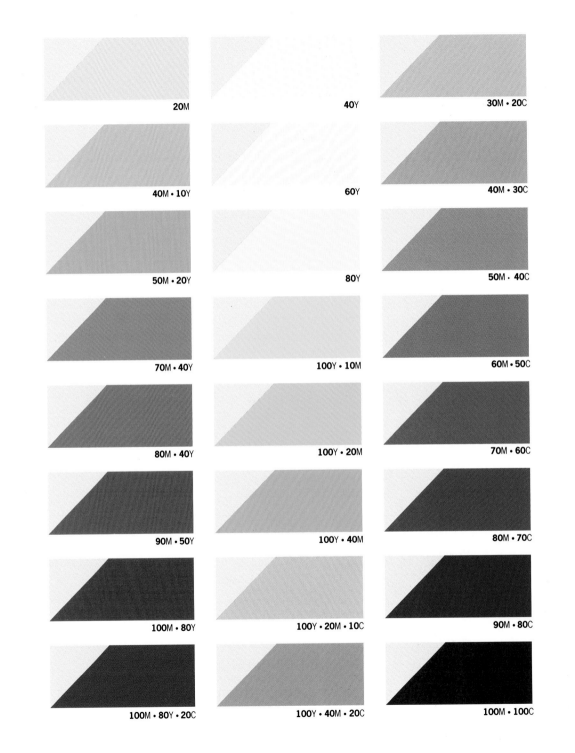

20M

40Y

30M · 20C

40M · 10Y

60Y

40M · 30C

50M · 20Y

80Y

50M · 40C

70M · 40Y

100Y · 10M

60M · 50C

80M · 40Y

100Y · 20M

70M · 60C

90M · 50Y

100Y · 40M

80M · 70C

100M · 80Y

100Y · 20M · 10C

90M · 80C

100M · 80Y · 20C

100Y · 40M · 20C

100M · 100C

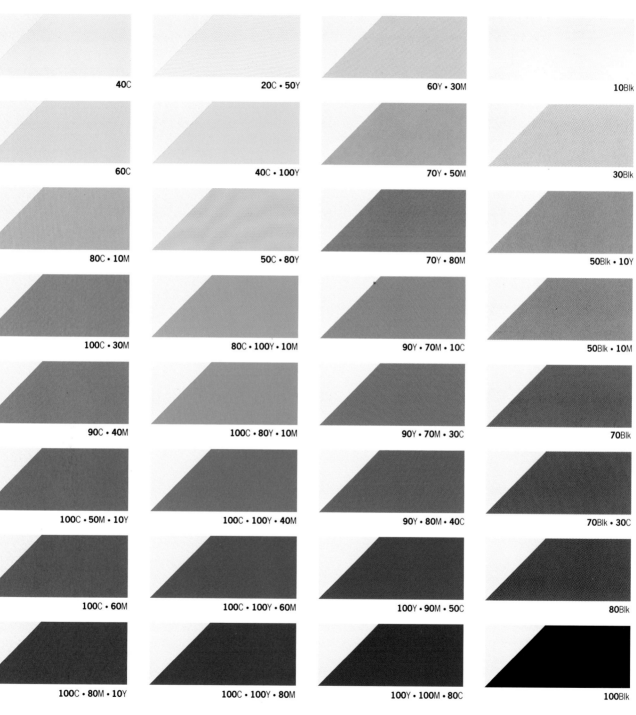

40C

20C · 50Y

60Y · 30M

10Blk

60C

40C · 100Y

70Y · 50M

30Blk

80C · 10M

50C · 80Y

70Y · 80M

50Blk · 10Y

100C · 30M

80C · 100Y · 10M

90Y · 70M · 10C

50Blk · 10M

90C · 40M

100C · 80Y · 10M

90Y · 70M · 30C

70Blk

100C · 50M · 10Y

100C · 100Y · 40M

90Y · 80M · 40C

70Blk · 30C

100C · 60M

100C · 100Y · 60M

100Y · 90M · 50C

80Blk

100C · 80M · 10Y

100C · 100Y · 80M

100Y · 100M · 80C

100Blk

NOTE: For technical information see page 6

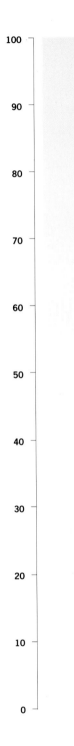

Ossidet sterio binignuis
tultia, dolorat isogult it
gignuntisin stinuand. Flourida
prat gerealiunt quaecumque
trutent artsquati, quiateire
lurorist de corspore orum
semi uitantque tueri; sol etiam
caecat contra osidetsal utiquite

Ossidet sterio binignuis
tultia, dolorat isogult it
gignuntisin stinuand. Flourida
prat gerealiunt quaecumque
trutent artsquati, quiateire
lurorist de corspore orum
semi uitantque tueri; sol etiam
caecat contra osidetsal utiquite

Ossidet sterio binignuis
tultia, dolorat isogult it
gignuntisin stinuand. Flourida
prat gereafiunt quaecumque
trutent artsquati, quiateire
lurorist de corspore orum
semi uitantque tueri; sol etiam
caecat contra osidetsal utiquite

Ossidet sterio binignuis
tultia, dolorat isogult it
gignuntisin stinuand. Flourida
prat gereafiunt quaecumque
trutent artsquati, quiateire
lurorist de corspore orum
semi uitantque tueri; sol etiam
caecat contra osidetsal utiquite

100Blk H/T • H/T's: **10**M • **10**C 100Blk H/T • H/T's: **5**M • **5**C

50Blk H/T • H/T's: **10**M • **10**C 50Blk H/T • H/T's: **5**M • **5**C

100Blk H/T • F/T's: **10**M • **10**C 100Blk H/T • F/T's: **5**M • **5**C

H/T's: **10**M • **10**C H/T's: **5**M • **5**C

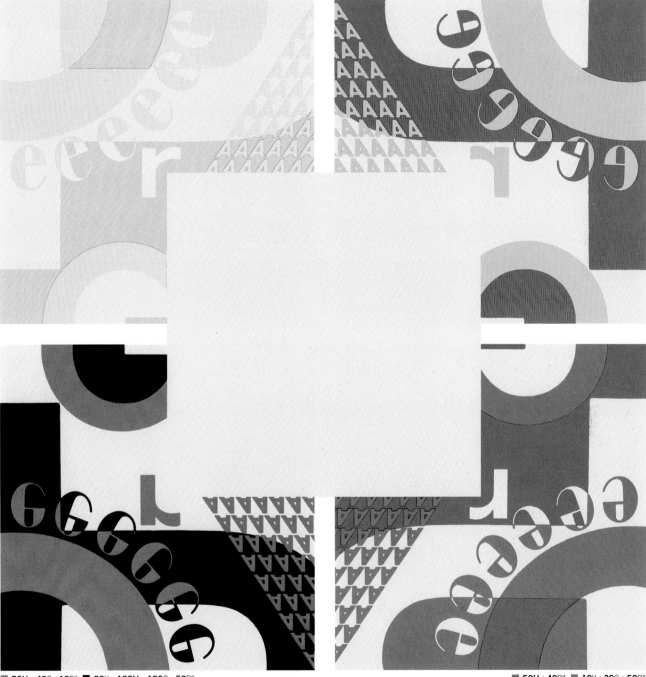

30Y • 20Blk 10M • 20C

30M 40M • 50Blk

50M • 40C • 10Blk 20Y • 100M • 100C • 50Blk

50M • 40Blk 10Y • 30C • 50Blk

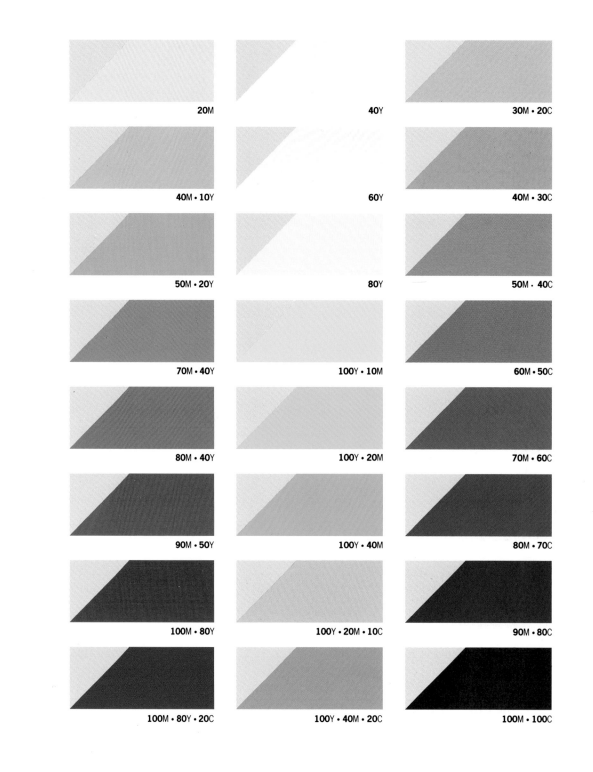

20M

40Y

30M · 20C

40M · 10Y

60Y

40M · 30C

50M · 20Y

80Y

50M · 40C

70M · 40Y

100Y · 10M

60M · 50C

80M · 40Y

100Y · 20M

70M · 60C

90M · 50Y

100Y · 40M

80M · 70C

100M · 80Y

100Y · 20M · 10C

90M · 80C

100M · 80Y · 20C

100Y · 40M · 20C

100M · 100C

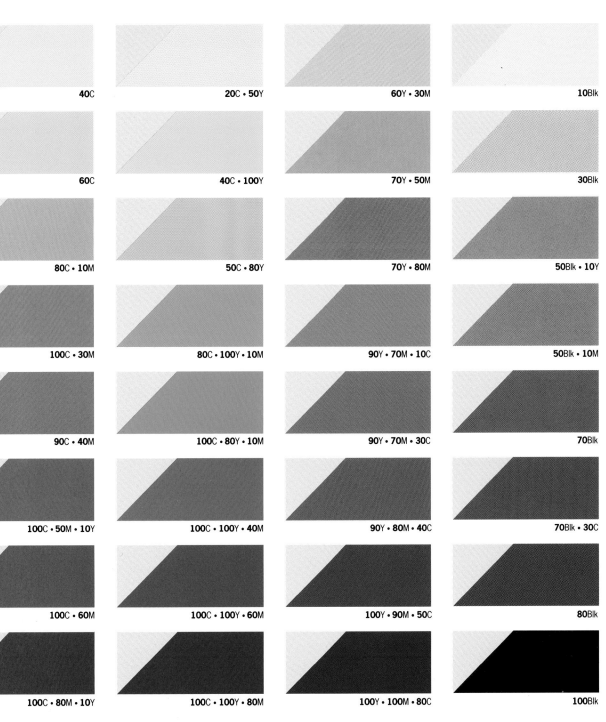

40C	20C · 50Y	60Y · 30M	10Blk
60C	40C · 100Y	70Y · 50M	30Blk
80C · 10M	50C · 80Y	70Y · 80M	50Blk · 10Y
100C · 30M	80C · 100Y · 10M	90Y · 70M · 10C	50Blk · 10M
90C · 40M	100C · 80Y · 10M	90Y · 70M · 30C	70Blk
100C · 50M · 10Y	100C · 100Y · 40M	90Y · 80M · 40C	70Blk · 30C
100C · 60M	100C · 100Y · 60M	100Y · 90M · 50C	80Blk
100C · 80M · 10Y	100C · 100Y · 80M	100Y · 100M · 80C	100Blk

NOTE: For technical information see page 6

Ossidet sterio binignuis
tultia, dolorat isogult it
gignuntisin stinuand. Flourida
prat gereafiunt quaecumque
trutent artsquati, quiateire
lurorist de corspore orum
semi uitantque tueri; sol etiam
caecat contra osidetsal utiquite

Ossidet sterio binignuis
tultia, dolorat isogult it
gignuntisin stinuand. Flourida
prat gereafiunt quaecumque
trutent artsquati, quiateire
lurorist de corspore orum
semi uitantque tueri; sol etiam
caecat contra osidetsal utiquite

Ossidet sterio binignuis
tultia, dolorat isogult it
gignuntisin stinuand. Flourida
prat gereafiunt quaecumque
trutent artsquati, quiateire
lurorist de corspore orum
semi uitantque tueri; sol etiam
caecat contra osidetsal utiquite

Ossidet sterio binignuis
tultia, dolorat isogult it
gignuntisin stinuand. Flourida
prat gereafiunt quaecumque
trutent artsquati, quiateire
lurorist de corspore orum
semi uitantque tueri; sol etiam
caecat contra osidetsal utiquite

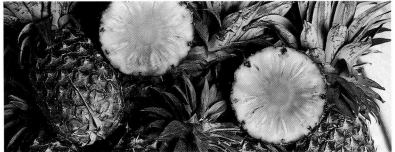

100Blk H/T · H/T's: **20**M · **10**C 100Blk H/T · H/T's: **10**M · **5**C

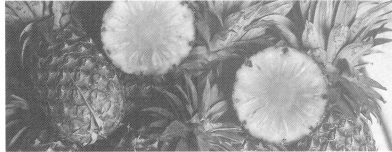

50Blk H/T · H/T's: **20**M · **10**C 50Blk H/T · H/T's: **10**M · **5**C

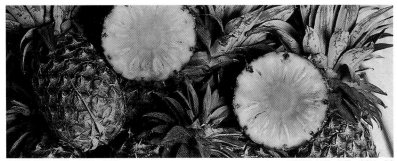

100Blk H/T · F/T's: **20**M · **10**C 100Blk H/T · F/T's: **10**M · **5**C

H/T's: **20**M · **10**C H/T's: **10**M · **5**C

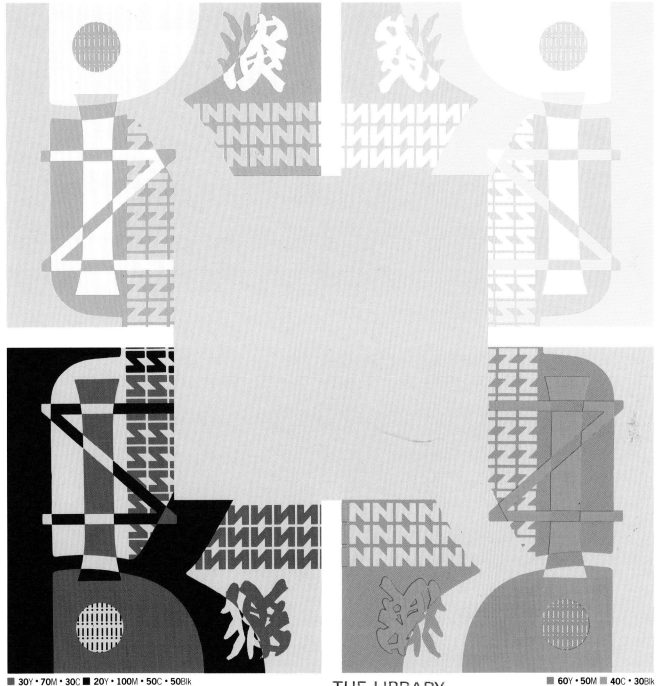

■ 30Y • 70M • 30C ■ 20Y • 100M • 50C • 50Blk

■ 60Y • 50M ■ 40C • 30Blk

20M · 20C

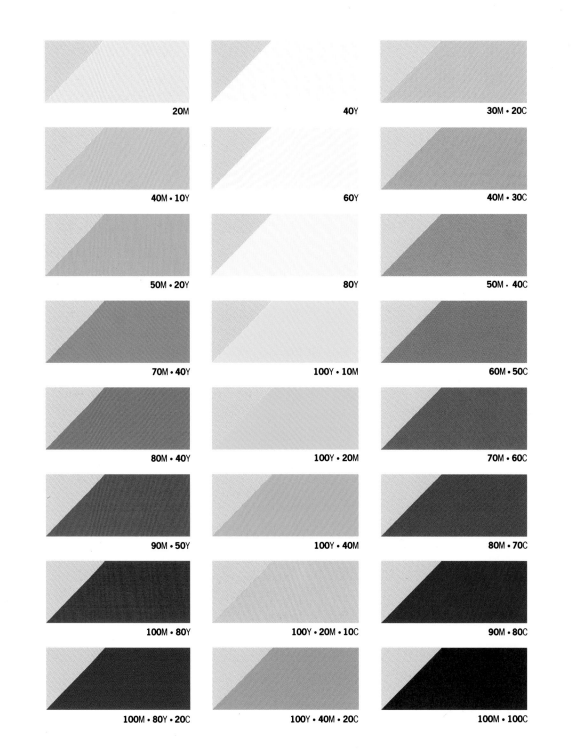

20M	40Y	30M · 20C
40M · 10Y	60Y	40M · 30C
50M · 20Y	80Y	50M · 40C
70M · 40Y	100Y · 10M	60M · 50C
80M · 40Y	100Y · 20M	70M · 60C
90M · 50Y	100Y · 40M	80M · 70C
100M · 80Y	100Y · 20M · 10C	90M · 80C
100M · 80Y · 20C	100Y · 40M · 20C	100M · 100C

40C

20C • 50Y

60Y • 30M

10Blk

60C

40C • 100Y

70Y • 50M

30Blk

80C • 10M

50C • 80Y

70Y • 80M

50Blk • 10Y

100C • 30M

80C • 100Y • 10M

90Y • 70M • 10C

50Blk • 10M

90C • 40M

100C • 80Y • 10M

90Y • 70M • 30C

70Blk

100C • 50M • 10Y

100C • 100Y • 40M

90Y • 80M • 40C

70Blk • 30C

100C • 60M

100C • 100Y • 60M

100Y • 90M • 50C

80Blk

100C • 80M • 10Y

100C • 100Y • 80M

100Y • 100M • 80C

100Blk

97

20M · 20C

NOTE: For technical information see page 6

Ossidet sterio binignuis tultia, dolorat isogult it gignuntisin stinuand. Flourida prat gereafiunt quaecumque trutent artsquati, quiateire lurorist de corspore orum semi uitantque tueri; sol etiam caecat contra osidetsal utiquite

Ossidet sterio binignuis tultia, dolorat isogult it gignuntisin stinuand. Flourida prat gereafiunt quaecumque trutent artsquati, quiateire lurorist de corspore orum semi uitantque tueri; sol etiam caecat contra osidetsal utiquite

Ossidet sterio binignuis tultia, dolorat isogult it gignuntisin stinuand. Flourida prat gereafiunt quaecumque trutent artsquati, quiateire lurorist de corspore orum semi uitantque tueri; sol etiam caecat contra osidetsal utiquite

Ossidet sterio binignuis tultia, dolorat isogult it gignuntisin stinuand. Flourida prat gereafiunt quaecumque trutent artsquati, quiateire lurorist de corspore orum semi uitantque tueri; sol etiam caecat contra osidetsal utiquite

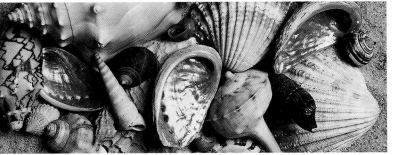

100Blk H/T • H/T's: **20M • 20**C 100Blk H/T • H/T's: **10M • 10**C

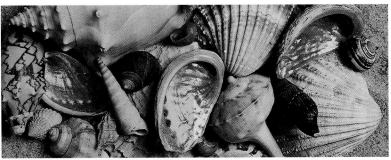

50Blk H/T • H/T's: **20M • 20**C 50Blk H/T • H/T's: **10M • 10**C

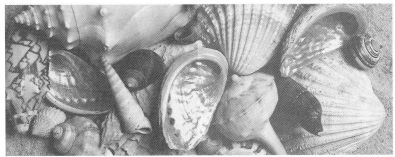

100Blk H/T • F/T's: **20M • 20**C 100Blk H/T • F/T's: **10M • 10**C

H/T's: **20M • 20**C H/T's: **10M • 10**C

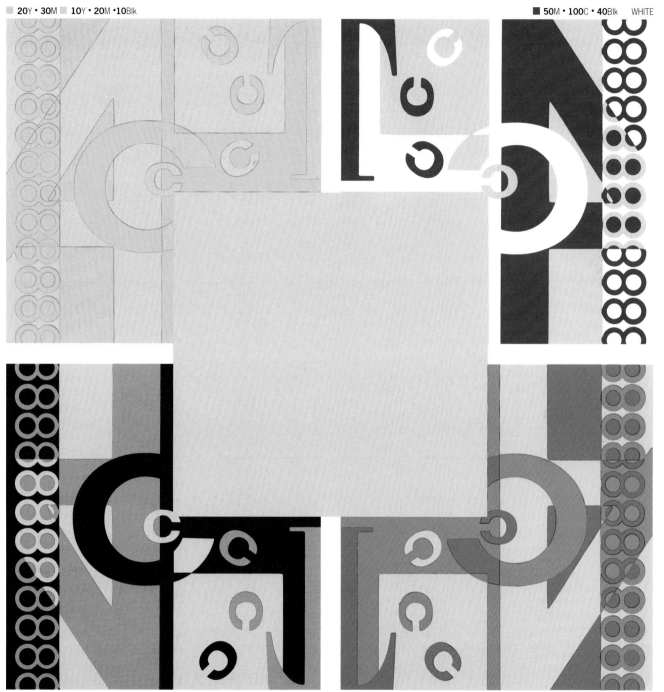

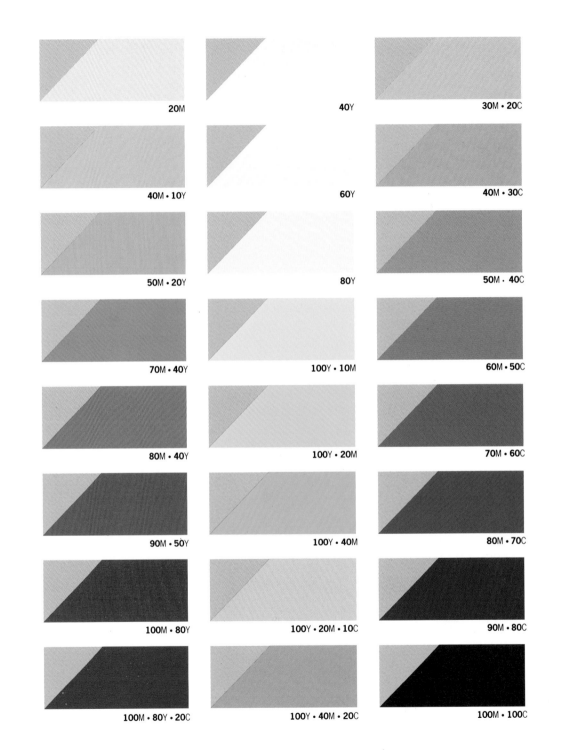

20M

40Y

30M · 20C

40M · 10Y

60Y

40M · 30C

50M · 20Y

80Y

50M · 40C

70M · 40Y

100Y · 10M

60M · 50C

80M · 40Y

100Y · 20M

70M · 60C

90M · 50Y

100Y · 40M

80M · 70C

100M · 80Y

100Y · 20M · 10C

90M · 80C

100M · 80Y · 20C

100Y · 40M · 20C

100M · 100C

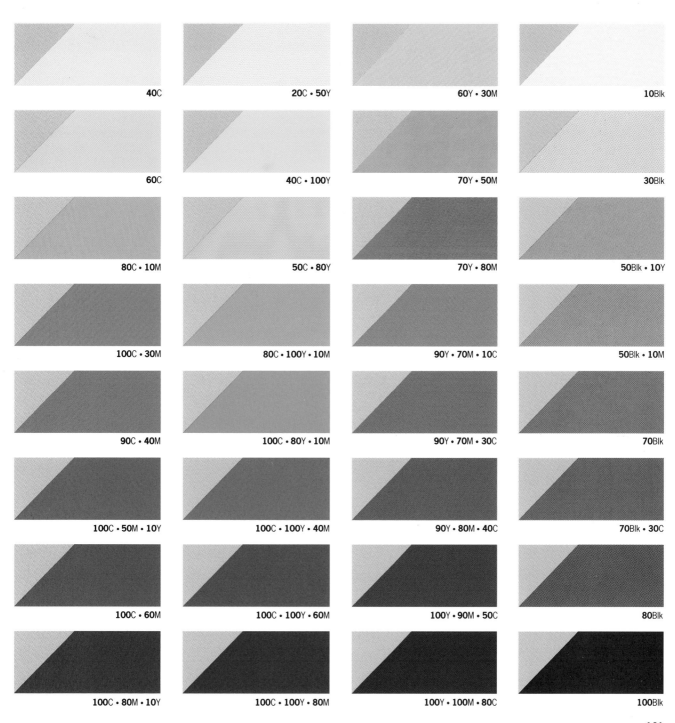

40C	20C • 50Y	60Y • 30M	10Blk
60C	40C • 100Y	70Y • 50M	30Blk
80C • 10M	50C • 80Y	70Y • 80M	50Blk • 10Y
100C • 30M	80C • 100Y • 10M	90Y • 70M • 10C	50Blk • 10M
90C • 40M	100C • 80Y • 10M	90Y • 70M • 30C	70Blk
100C • 50M • 10Y	100C • 100Y • 40M	90Y • 80M • 40C	70Blk • 30C
100C • 60M	100C • 100Y • 60M	100Y • 90M • 50C	80Blk
100C • 80M • 10Y	100C • 100Y • 80M	100Y • 100M • 80C	100Blk

30M · 30C

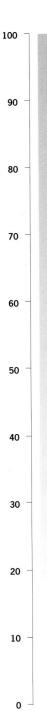

NOTE: For technical information see page 6

Ossidet sterio binignuis tultia, dolorat isogult it gignuntisin stinuand. Flourida prat gereafiunt quaecumque trutent artsquati, quiateire lurorist de corspore orum semi uitantque tueri; sol etiam caecat contra osidetsal utiquite

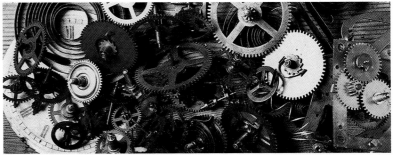

100Blk H/T • H/T's: **30M** • **30C** 100Blk H/T • H/T's: **15M** • **15C**

Ossidet sterio binignuis tultia, dolorat isogult it gignuntisin stinuand. Flourida prat gereafiunt quaecumque trutent artsquati, quiateire lurorist de corspore orum semi uitantque tueri; sol etiam caecat contra osidetsal utiquite

50Blk H/T • H/T's: **30M** • **30C** 50Blk H/T • H/T's: **15M** • **15C**

Ossidet sterio binignuis tultia, dolorat isogult it gignuntisin stinuand. Flourida prat gereafiunt quaecumque trutent artsquati, quiateire lurorist de corspore orum semi uitantque tueri; sol etiam caecat contra osidetsal utiquite

100Blk H/T • F/T's: **30M** • **30C** 100Blk H/T • F/T's: **15M** • **15C**

Ossidet sterio binignuis tultia, dolorat isogult it gignuntisin stinuand. Flourida prat gereafiunt quaecumque trutent artsquati, quiateire lurorist de corspore orum semi uitantque tueri; sol etiam caecat contra osidetsal utiquite

H/T's: **30M** • **30C** H/T's: **15M** • **15C**

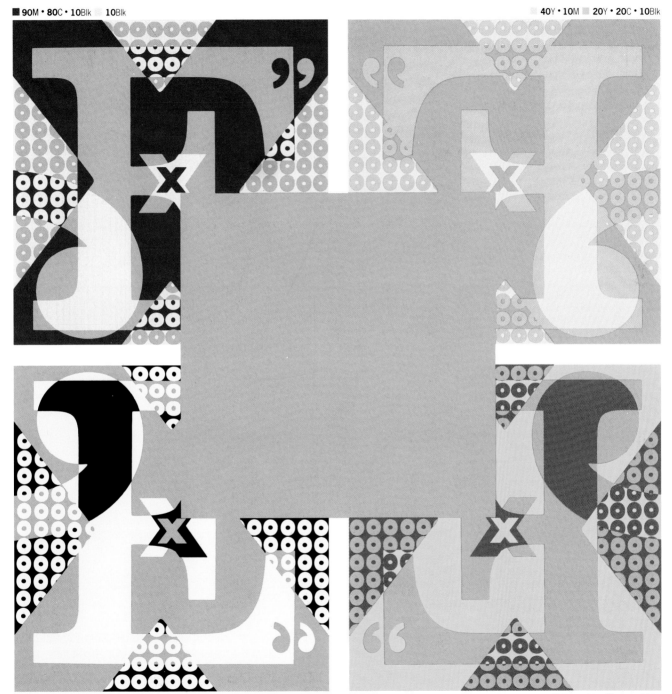

"Sugar and spice and everything nice" from nutmeg to lavender. Whether adding mysterious tints to monochrome or interest and warmth to white, these shades never fail to fascinate.

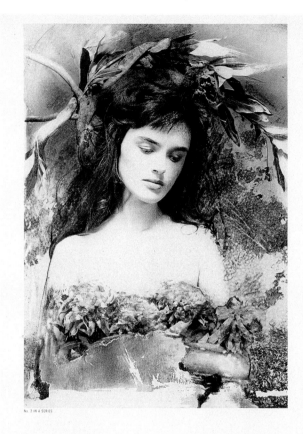

No. 7 IN A SERIES

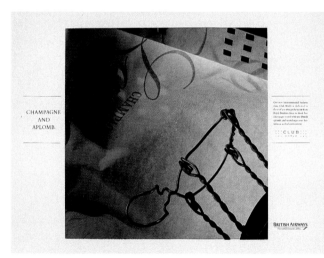

CHAMPAGNE
AND
APLOMB.

BRITISH AIRWAYS

▲ A warm and sophisticated tint, rather than the harsh literal lighting of monochrome, makes this more than just a still life. By using lilac, the designer has subtly evoked a safe and secure atmosphere as well as referring to the sophistication and excitement of pink champagne.

◀ These mauve cubes have a strongly illusory effect when combined with white. At first they are simply cubes, on second glance they become hexagons split by the letter "Y". The use of a sophisticated shade such as mauve for geometric graphics is unusual and adds to the optical illusion.

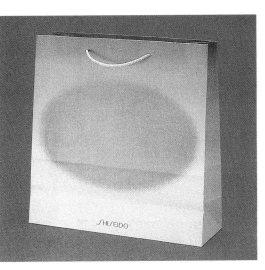

◀ A cloud of heather-mist pink across white is given depth and personality by the addition of mauve to the background. The atmosphere and imagery encapsulate the message of this cosmetic company; captions are unnecessary.

...nce (HG 4758/6) interpreted ...rapher David Hiscock

◀ The dreamy, sensuous quality of this image is enhanced by the blending of lavender and lilac shades tangled around alabaster skin tones, and sepia roses juxtaposed sympathetically with auburn hair. Indigo handwriting brings an intimate touch to the facing page (an understatement after the fullness of the facing image) reinforced by a touch of toning rose for the logo.

F TOMORROW'S SUCCÈS FOU

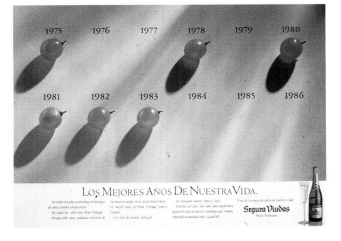

LOS MEJORES AÑOS DE NUESTRA VIDA.

Segura Viudas

▲ Prismatic rays of lilac light radiate from amber gold grapes. The warmth of the colour brings the grapes to life, implying that they have special powers and will produce a splendid wine. Lilac and amber form an original and unusual colour palette which contrasts with conventional graphics and text on the white banner below.

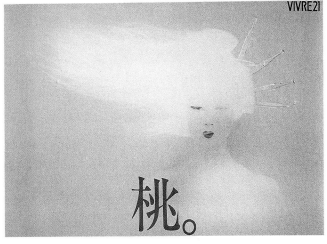

VIVRE 21

桃。

◀ The lilac background and the white central image fuse into one. The icy whiteness of the hair and torso project, while the lilac-toned face contrasts with the pure red of the lips and eye make-up. Violet-grey calligraphy underlines the coldness of the image.

20M

40Y

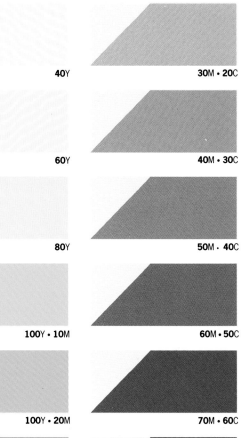

30M • 20C

40M • 10Y

60Y

40M • 30C

50M • 20Y

80Y

50M • 40C

70M • 40Y

100Y • 10M

60M • 50C

80M • 40Y

100Y • 20M

70M • 60C

90M • 50Y

100Y • 40M

80M • 70C

100M • 80Y

100Y • 20M • 10C

90M • 80C

100M • 80Y • 20C

100Y • 40M • 20C

100M • 100C

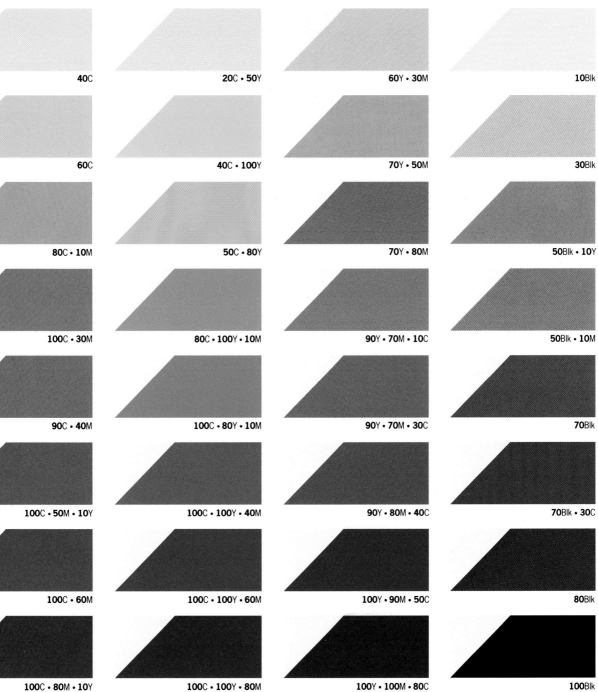

40C	20C • 50Y	60Y • 30M	10Blk
60C	40C • 100Y	70Y • 50M	30Blk
80C • 10M	50C • 80Y	70Y • 80M	50Blk • 10Y
100C • 30M	80C • 100Y • 10M	90Y • 70M • 10C	50Blk • 10M
90C • 40M	100C • 80Y • 10M	90Y • 70M • 30C	70Blk
100C • 50M • 10Y	100C • 100Y • 40M	90Y • 80M • 40C	70Blk • 30C
100C • 60M	100C • 100Y • 60M	100Y • 90M • 50C	80Blk
100C • 80M • 10Y	100C • 100Y • 80M	100Y • 100M • 80C	100Blk

NOTE: For technical information see page 6

100Blk H/T • H/T's: **10**C **100**Blk H/T • H/T's: **5**C

50Blk H/T • H/T's: **10**C **50**Blk H/T • H/T's: **5**C

100Blk H/T • F/T's: **10**C **100**Blk H/T • F/T's: **5**C

Ossidet sterio binignuis tultia, dolorat isogult it gignuntisin stinuand. Flourida prat gereafiunt quaecumque trutent artsquati, quiateire lurorist de corspore orum semi uitantque tueri; sol etiam caecat contra osidetsal utiquite

Ossidet sterio binignuis tultia, dolorat isogult it gignuntisin stinuand. Flourida prat gereafiunt quaecumque trutent artsquati, quiateire lurorist de corspore orum semi uitantque tueri; sol etiam caecat contra osidetsal utiquite

H/T's: **10**C H/T's: **5**C

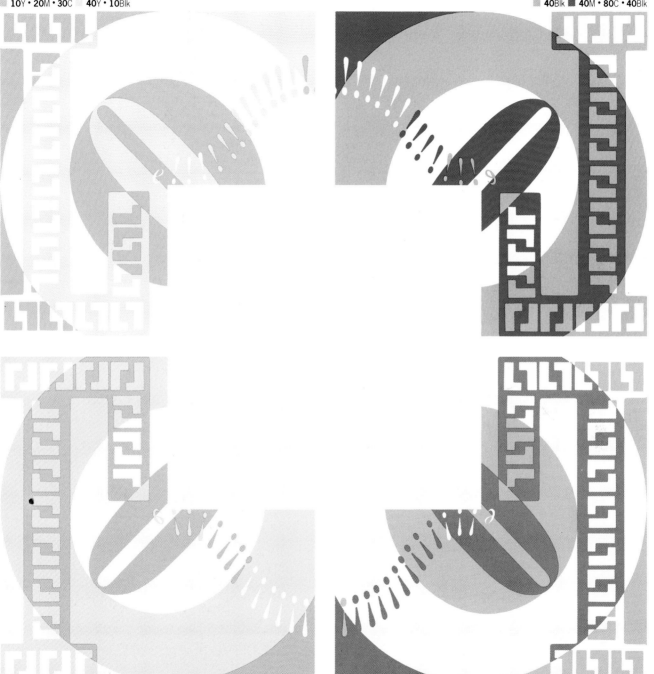

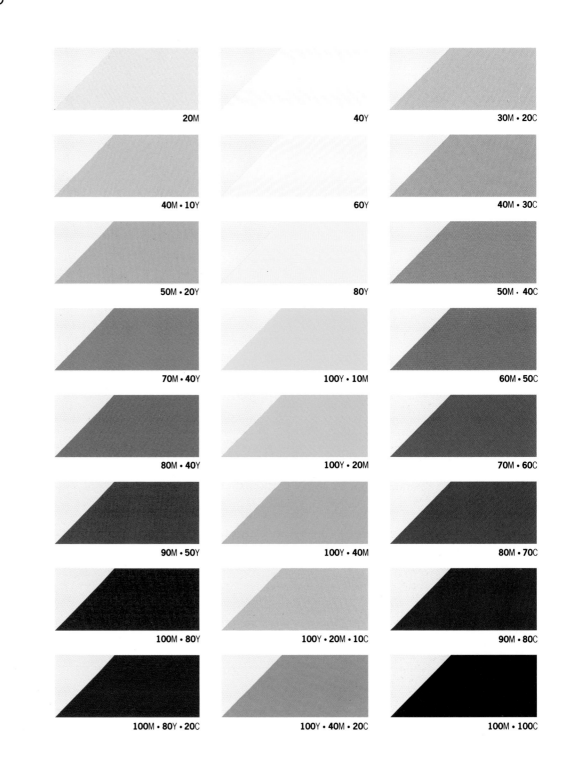

20M

40Y

30M • 20C

40M • 10Y

60Y

40M • 30C

50M • 20Y

80Y

50M • 40C

70M • 40Y

100Y • 10M

60M • 50C

80M • 40Y

100Y • 20M

70M • 60C

90M • 50Y

100Y • 40M

80M • 70C

100M • 80Y

100Y • 20M • 10C

90M • 80C

100M • 80Y • 20C

100Y • 40M • 20C

100M • 100C

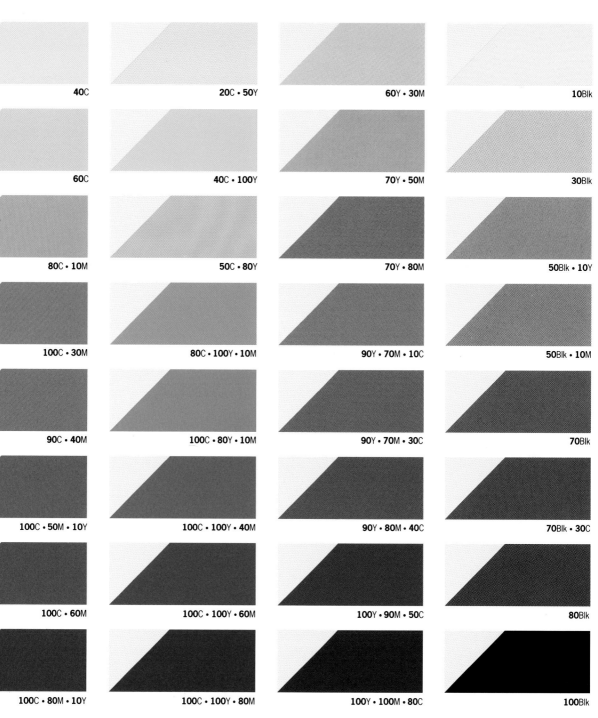

40C

20C • 50Y

60Y • 30M

10Blk

60C

40C • 100Y

70Y • 50M

30Blk

80C • 10M

50C • 80Y

70Y • 80M

50Blk • 10Y

100C • 30M

80C • 100Y • 10M

90Y • 70M • 10C

50Blk • 10M

90C • 40M

100C • 80Y • 10M

90Y • 70M • 30C

70Blk

100C • 50M • 10Y

100C • 100Y • 40M

90Y • 80M • 40C

70Blk • 30C

100C • 60M

100C • 100Y • 60M

100Y • 90M • 50C

80Blk

100C • 80M • 10Y

100C • 100Y • 80M

100Y • 100M • 80C

100Blk

NOTE: For technical information see page 6

100
90
80
70
60
50
40
30
20
10
0

Ossidet sterio binignuis tultia, dolorat isogult it gignuntisin stinuand. Flourida prat gereafiunt quaecumque trutent artsquati, quiateire lurorist de corspore orum semi uitantque tueri; sol etiam caecat contra osidetsal utiquite

Ossidet sterio binignuis tultia, dolorat isogult it gignuntisin stinuand. Flourida prat gereafiunt quaecumque trutent artsquati, quiateire lurorist de corspore orum semi uitantque tueri; sol etiam caecat contra osidetsal utiquite

100Blk H/T • H/T's: **20**C 100Blk H/T • H/T's: **10**C

50Blk H/T • H/T's: **20**C 50Blk H/T • H/T's: **10**C

100Blk H/T • F/T's: **20**C 100Blk H/T • F/T's: **10**C

H/T's: **20**C H/T's: **10**C

The gentlest tone of ice blue brings subtle colour to the design. When the percentage is increased, the shade takes on some warmth and intensity.

▶ Shades of rose madder and terracotta harmonize around a discordant array of images. The black typography and banners are clear but harsh, and so require the addition of sky blue graphics to soften the black and bring life and warmth to the entire cover.

▼ A classic approach to colour and design has been taken here. The strong black graphics combined with pastels acknowledge both Bauhaus and the Art Deco movement. However the dominant position given to the pastel blue, under the pale salmon banner, gives the entire image a contemporary feel as well as strong visibility.

▲ The "emerging voices" struggle to escape from the suffocating ice blue covering. Shades of the same blue create a textured effect and strengthen the illusion of words being pushed outward.

▲ Soft pale tints of blue create textural background for the black typography. The romantic pink tones of a floral border form a contrast to the pure, clean pastel blues.

▼ Two-colour process printing is used with originality to produce an image that is both abstract and representational. A gentle pattern of tints on pastel sky blue provides a soft textural background from which the central image can fly.

THE DEVIL IN ME
0-58
POW-WOW
THREE PIECE SWING
1-20

1-37
IN SMOKE
1-59
LENGTH OF TIME
1-34

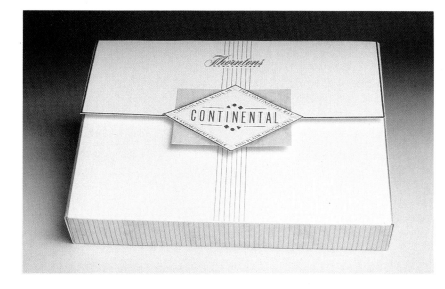

◄ Pastels and confectionery have always had a strong association. By combining a traditional colour such as sugar blue with pure white and subtle grey graphics, the designer has created an entirely new concept for chocolate packaging. The pure, elegant appearance appeals to both sexes.

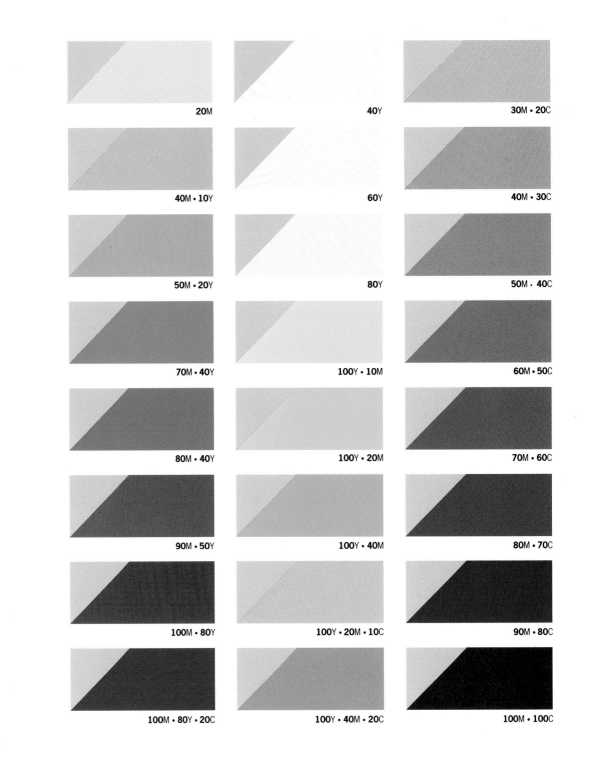

20M

40Y

30M · 20C

40M · 10Y

60Y

40M · 30C

50M · 20Y

80Y

50M · 40C

70M · 40Y

100Y · 10M

60M · 50C

80M · 40Y

100Y · 20M

70M · 60C

90M · 50Y

100Y · 40M

80M · 70C

100M · 80Y

100Y · 20M · 10C

90M · 80C

100M · 80Y · 20C

100Y · 40M · 20C

100M · 100C

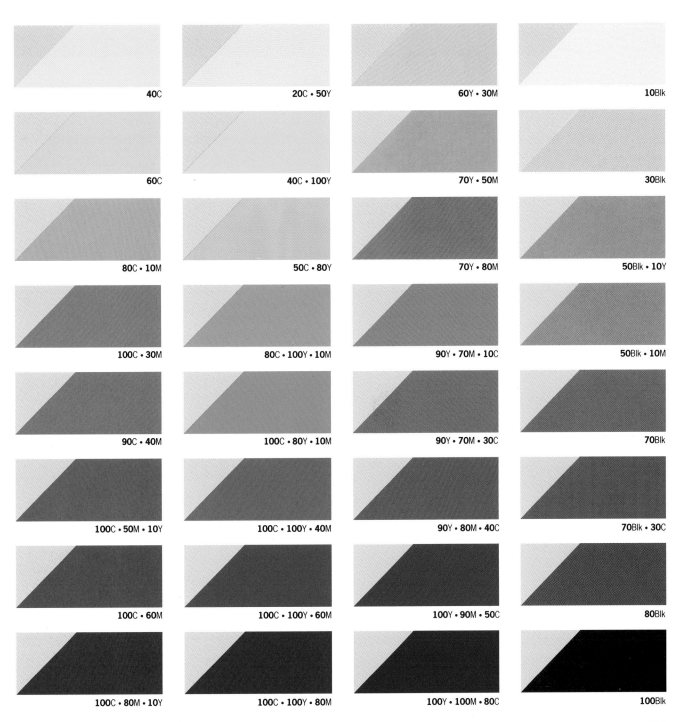

40C	20C • 50Y	60Y • 30M	10Blk
60C	40C • 100Y	70Y • 50M	30Blk
80C • 10M	50C • 80Y	70Y • 80M	50Blk • 10Y
100C • 30M	80C • 100Y • 10M	90Y • 70M • 10C	50Blk • 10M
90C • 40M	100C • 80Y • 10M	90Y • 70M • 30C	70Blk
100C • 50M • 10Y	100C • 100Y • 40M	90Y • 80M • 40C	70Blk • 30C
100C • 60M	100C • 100Y • 60M	100Y • 90M • 50C	80Blk
100C • 80M • 10Y	100C • 100Y • 80M	100Y • 100M • 80C	100Blk

NOTE: For technical information see page 6

100

90

80

70

60

50

40

30

20

10

0

Ossidet sterio binignuis
tultia, dolorat isogult it
gignuntisin stinuand. Flourida
prat gereafiunt quaecumque
trutent artsquati, quiateire
lurorist de corspore orum
semi uitantque tueri; sol etiam
caecat contra osidetsal utiquite

Ossidet sterio binignuis
tultia, dolorat isogult it
gignuntisin stinuand. Flourida
prat gereafiunt quaecumque
trutent artsquati, quiateire
lurorist de corspore orum
semi uitantque tueri; sol etiam
caecat contra osidetsal utiquite

Ossidet sterio binignuis
tultia, dolorat isogult it
gignuntisin stinuand. Flourida
prat gereafiunt quaecumque
trutent artsquati, quiateire
lurorist de corspore orum
semi uitantque tueri; sol etiam
caecat contra osidetsal utiquite

Ossidet sterio binignuis
tultia, dolorat isogult it
gignuntisin stinuand. Flourida
prat gereafiunt quaecumque
trutent artsquati, quiateire
lurorist de corspore orum
semi uitantque tueri; sol etiam
caecat contra osidetsal utiquite

100Blk H/T • H/T's: **10**M • **40**C 100Blk H/T • H/T's: **5**M • **20**C

50Blk H/T • H/T's: **10**M • **40**C 50Blk H/T • H/T's: **5**M • **20**C

100Blk H/T • F/T's: **10**M • **40**C 100Blk H/T • F/T's: **5**M • **20**C

H/T's: **10**M • **40**C H/T's: **5**M • **20**C

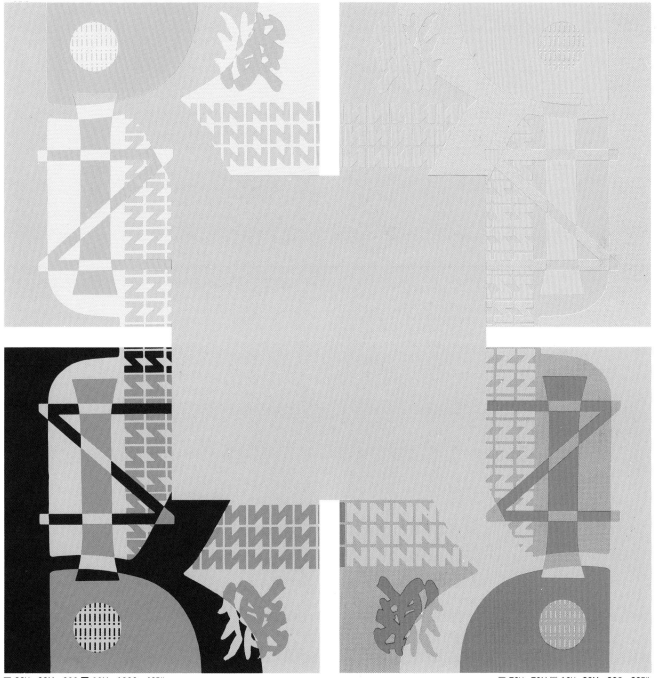

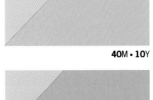

20M

40Y

30M · 20C

40M · 10Y

60Y

40M · 30C

50M · 20Y

80Y

50M · 40C

70M · 40Y

100Y · 10M

60M · 50C

80M · 40Y

100Y · 20M

70M · 60C

90M · 50Y

100Y · 40M

80M · 70C

100M · 80Y

100Y · 20M · 10C

90M · 80C

100M · 80Y · 20C

100Y · 40M · 20C

100M · 100C

 40C

 20C · 50Y

 60Y · 30M

10Blk

 60C

40C · 100Y

 70Y · 50M

30Blk

80C · 10M

50C · 80Y

70Y · 80M

50Blk · 10Y

 100C · 30M

80C · 100Y · 10M

 90Y · 70M · 10C

50Blk · 10M

90C · 40M

100C · 80Y · 10M

 90Y · 70M · 30C

70Blk

100C · 50M · 10Y

100C · 100Y · 40M

90Y · 80M · 40C

70Blk · 30C

 100C · 60M

 100C · 100Y · 60M

100Y · 90M · 50C

80Blk

 100C · 80M · 10Y

100C · 100Y · 80M

 100Y · 100M · 80C

100Blk

50C

100 —
90 —
80 —
70 —
60 —
50 —
40 —
30 —
20 —
10 —
0 —

Ossidet sterio binignuis tultia, dolorat isogult it gignuntisin stinuand. Flourida prat gereafiunt quaecumque trutent artsquati, quiateire lurorist de corspore orum semi uitantque tueri; sol etiam caecat contra osidetsal utiquite

Ossidet sterio binignuis tultia, dolorat isogult it gignuntisin stinuand. Flourida prat gereafiunt quaecumque trutent artsquati, quiateire lurorist de corspore orum semi uitantque tueri; sol etiam caecat contra osidetsal utiquite

Ossidet sterio binignuis tultia, dolorat isogult it gignuntisin stinuand. Flourida prat gereafiunt quaecumque trutent artsquati, quiateire lurorist de corspore orum semi uitantque tueri; sol etiam caecat contra osidetsal utiquite

Ossidet sterio binignuis tultia, dolorat isogult it gignuntisin stinuand. Flourida prat gereafiunt quaecumque trutent artsquati, quiateire lurorist de corspore orum semi uitantque tueri; sol etiam caecat contra osidetsal utiquite

100Blk H/T • H/T's: **50C** 100Blk H/T • H/T's: **25C**

50Blk H/T • H/T's: **50C** 50Blk H/T • H/T's: **25C**

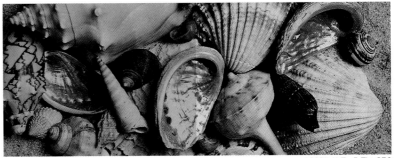

100Blk H/T • F/T's: **50C** 100Blk H/T • F/T's: **25C**

H/T's: **50C** H/T's: **25C**

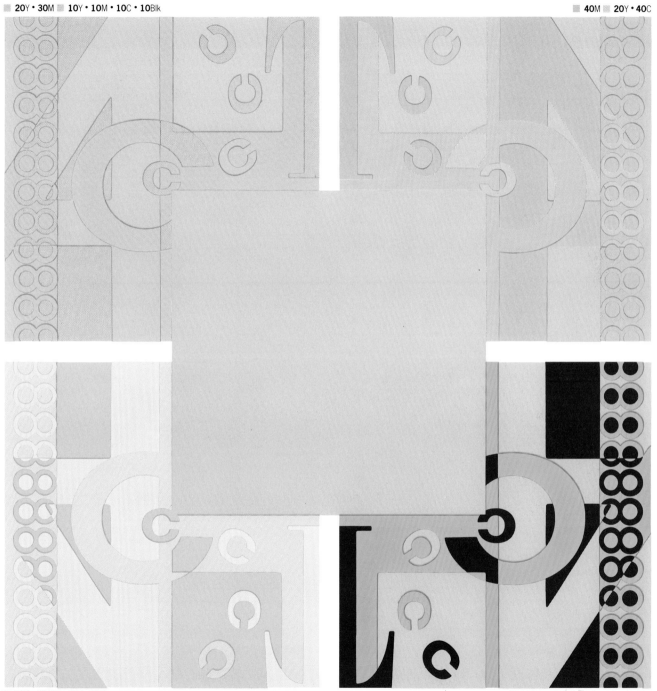

20Y • 30M 10Y • 10M • 10C • 10Blk

40M 20Y • 40C

30Y • 10M 30Y • 20C

100Y • 40M 70Y • 100M • 50Blk

Sky and watercolour blue stir the imagination. ● *They are sympathetic to soft tones and to harsher primaries.*

▼ Celebration erupts with clarity and confidence against a clear blue background. The blue forms a backdrop of sky which projects the pure white dress and primary graphics.

▶ This clean, pure pale blue on textured packaging creates the impression of watercolour paint. The natural wood tones of the pencils imply fine quality and traditional artistry.

completing the form . . .

IF YOU WISH TO PAY IN CASH:
Hand in the form, together with the sum you wish to send and the appropriate charge, at your local Post Office. Remember to keep the stamped counterfoil safely.

TO PAY BY CHEQUE:
Send the form and remittance directly to International Services, Girobank Plc, Bootle, Merseyside GIR 0AA. Make the cheque payable to Girobank Plc and don't forget to include the appropriate charge. For further information on the payments methods available abroad, please see the section "which way to pay".

Fill in both sides of the application form, in block capitals please.

enquiries

All enquiries should be addressed in writing to International Services, Girobank Plc, Bootle, Merseyside GIR 0AA, or you may telephone Customer Services on 051 933 3330. It is essential to quote the reference number from your counterfoil, so please remember to keep it somewhere safe. If for any reason a transaction is unpaid, the Bank will, after confirmation of stop payment, or returned cheque, repay its sterling value less any charges at the buying rate on the day the refund takes place. Other conditions upon which this service is provided are published in the current edition of the Post Office Guide and conditions contained in this leaflet shall supersede those contained in the Post Office Guide where inconsistent with it.

which way to pay

Cash payments and transfers will be sent directly abroad. However, the process involved means that there may sometimes be a short delay. Foreign cheques will, of course, be sent to you, for forwarding at your own convenience.

If you wish to send money to a country not shown, payment will be made by bank cheque in US Dollars, Sterling, or an appropriate alternative currency at Girobank's discretion.

COUNTRY	CASH	CHEQUE	GIRO TRANSFER
AUSTRIA	●	●	●
AUSTRALIA		●	●
BANGLADESH		●	
BELGIUM	●		●
CANADA		●	●
CYPRUS		●	
DENMARK	●	●	●
FINLAND		●	●
FRANCE	●	●	●
GREECE		●	
HONG KONG		●	
ICELAND	●		●
INDIA		●	
IRISH REPUBLIC		●	●
ITALY		●	●
JAPAN		●	●
LUXEMBOURG	●	●	●
MALTA		●	
MOROCCO	●	●	●
NETHERLANDS		●	●
NEW ZEALAND		●	●
NORWAY	●	●	●
PAKISTAN		●	
PORTUGAL		●	●
SINGAPORE		●	●
SOUTH AFRICA		●	
SPAIN	●	●	●
SWEDEN		●	●
SWITZERLAND	●	●	●
THAILAND		●	
TURKEY	●		●
WEST GERMANY	●	●	●
USA		●	●
YUGOSLAVIA	●		

NB

◀ Contrasting tones of medium and pastel blues create an effective and informative page. Turquoise graphics provide clarity on both the cornflower border and the harmonious wave of lilac and white, while the cornflower blue graphics and type bring strength and authority. The soft pastel shades in the background reveal a contemporary approach to dimension and intensity.

▶ Evocative images of New York buildings, recreated in pastel watercolour shades, fill the page with imagination and humour. The clarity and strength of the pale blue gives shape and context to the contents. The harmonious rose madder and primrose tints provide a supportive base.

WIND ENERGY TECHNOLOGY

(body text in illustration largely illegible)

Wind Energy

Wind Turbines

Technical Potential

▲ Sky blue, used in its literal sense, brings a sense of purity and movement to the billowing white clouds. The addition of powder blue for the diagram's background strengthens the overall clarity of the sky blue, while projecting the highly visible white graphics.

さかなにのまれた
ヨナのはなし

栗原マサ子再話　W.ハットン絵

▲ The strength of the Mediterranean blue wash enhances the whiteness of the surf while highlighting the grey of the whale. The addition of chrome yellow strokes to the white foam breaks the intensity of the blue, reminds us of the sun, and opposes the pastel pink. The pink of the whale's mouth and the figure of Jonah tones with the blue of the water, bringing a sense of calm to what could be a frightening image.

Contents

Project & People
Pick
In-House
Training & Planning
Systems & Design
Specialist Seminars
Booking

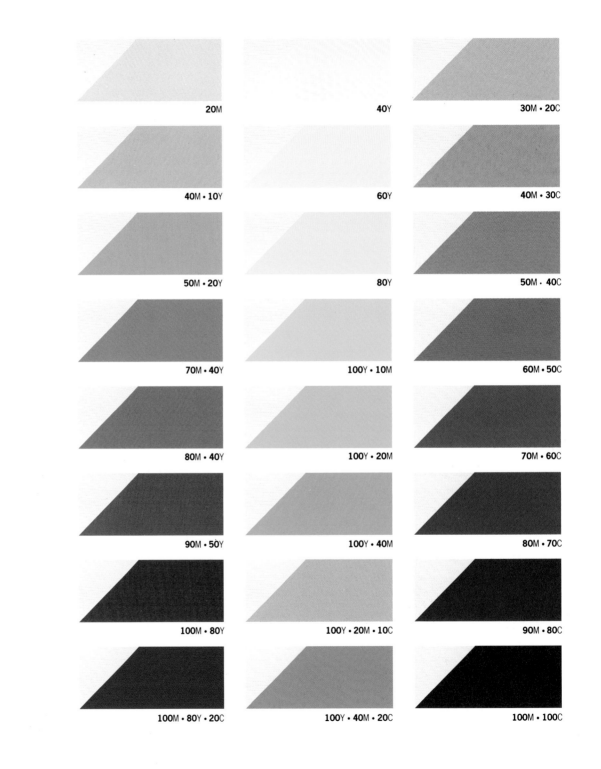

20M

40Y

30M · 20C

40M · 10Y

60Y

40M · 30C

50M · 20Y

80Y

50M · 40C

70M · 40Y

100Y · 10M

60M · 50C

80M · 40Y

100Y · 20M

70M · 60C

90M · 50Y

100Y · 40M

80M · 70C

100M · 80Y

100Y · 20M · 10C

90M · 80C

100M · 80Y · 20C

100Y · 40M · 20C

100M · 100C

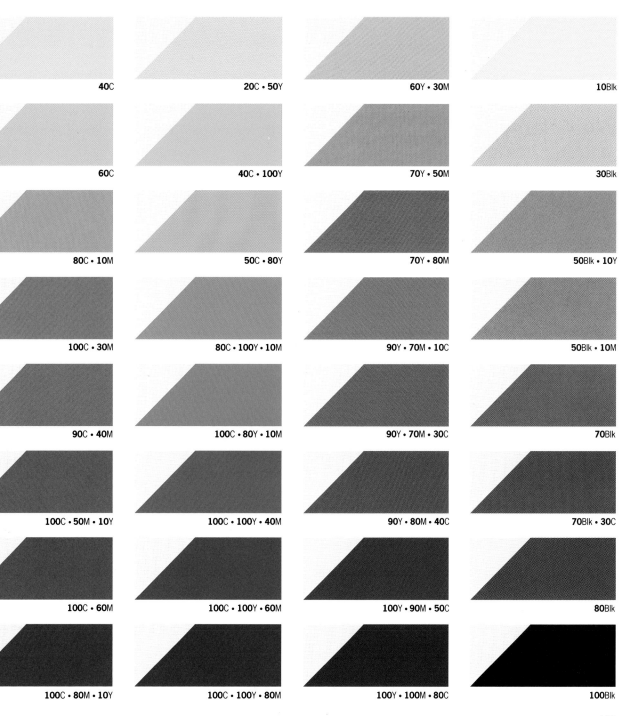

40C	20C • 50Y	60Y • 30M	10Blk
60C	40C • 100Y	70Y • 50M	30Blk
80C • 10M	50C • 80Y	70Y • 80M	50Blk • 10Y
100C • 30M	80C • 100Y • 10M	90Y • 70M • 10C	50Blk • 10M
90C • 40M	100C • 80Y • 10M	90Y • 70M • 30C	70Blk
100C • 50M • 10Y	100C • 100Y • 40M	90Y • 80M • 40C	70Blk • 30C
100C • 60M	100C • 100Y • 60M	100Y • 90M • 50C	80Blk
100C • 80M • 10Y	100C • 100Y • 80M	100Y • 100M • 80C	100Blk

NOTE: For technical information see page 6

100Blk H/T • H/T's: **10**Y • **10**C 100Blk H/T • H/T's: **5**Y • **5**C

50Blk H/T • H/T's: **10**Y • **10**C 50Blk H/T • H/T's: **5**Y • **5**C

Ossidet sterio binignuis tultia, dolorat isogult it gignuntisin stinuand. Flourida prat gereafiunt quaecumque **trutent artsquati, quiateire lurorist de corspore orum** semi uitantque tueri; sol etiam caecat contra osidetsal utiquite

100Blk H/T • F/T's: **10**Y • **10**C 100Blk H/T • F/T's: **5**Y • **5**C

Ossidet sterio binignuis tultia, dolorat isogult it gignuntisin stinuand. Flourida prat gereafiunt quaecumque **trutent artsquati, quiateire lurorist de corspore orum** semi uitantque tueri; sol etiam caecat contra osidetsal utiquite

H/T's: **10**Y • **10**C H/T's: **5**Y • **5**C

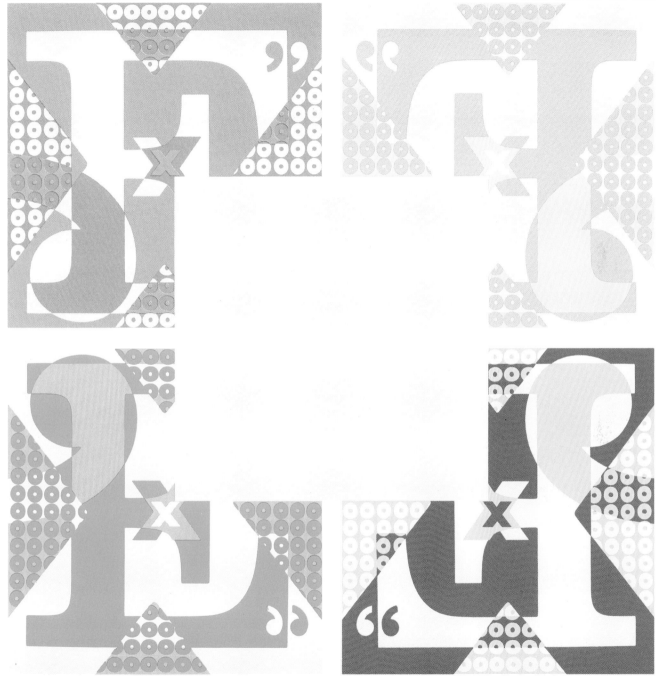

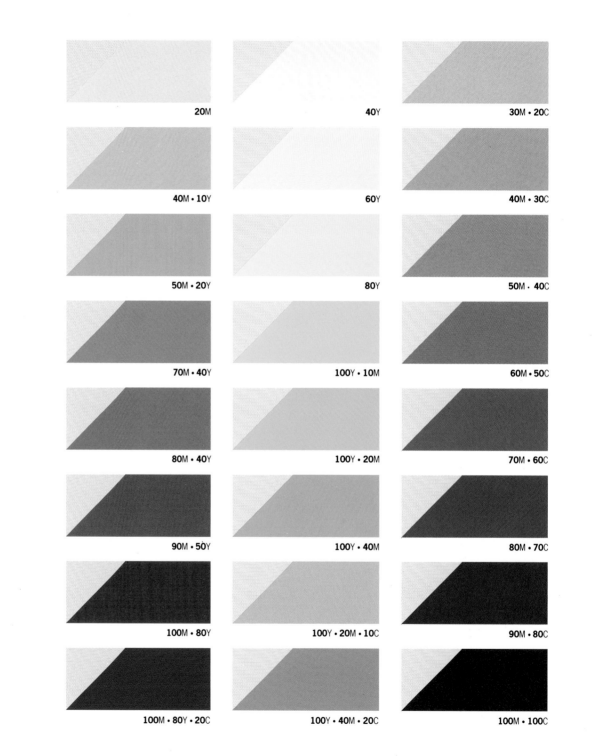

20M

40Y

30M · 20C

40M · 10Y

60Y

40M · 30C

50M · 20Y

80Y

50M · 40C

70M · 40Y

100Y · 10M

60M · 50C

80M · 40Y

100Y · 20M

70M · 60C

90M · 50Y

100Y · 40M

80M · 70C

100M · 80Y

100Y · 20M · 10C

90M · 80C

100M · 80Y · 20C

100Y · 40M · 20C

100M · 100C

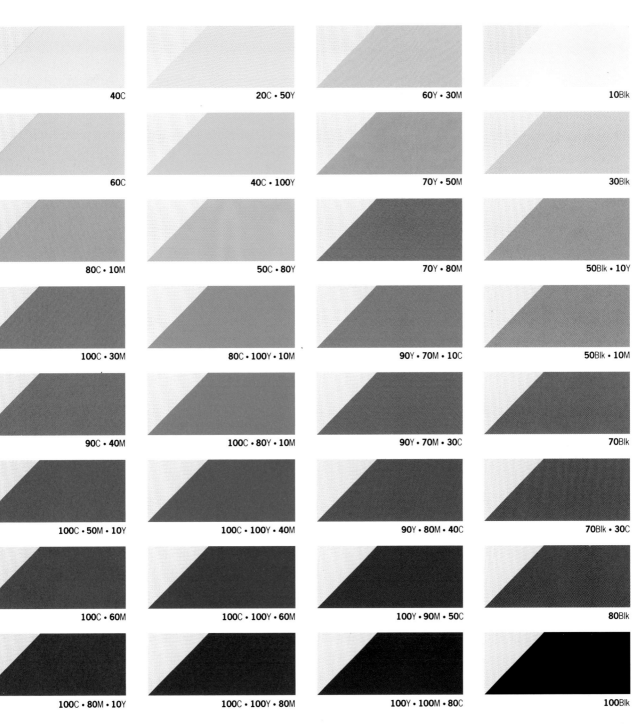

40C	20C · 50Y	60Y · 30M	10Blk
60C	40C · 100Y	70Y · 50M	30Blk
80C · 10M	50C · 80Y	70Y · 80M	50Blk · 10Y
100C · 30M	80C · 100Y · 10M	90Y · 70M · 10C	50Blk · 10M
90C · 40M	100C · 80Y · 10M	90Y · 70M · 30C	70Blk
100C · 50M · 10Y	100C · 100Y · 40M	90Y · 80M · 40C	70Blk · 30C
100C · 60M	100C · 100Y · 60M	100Y · 90M · 50C	80Blk
100C · 80M · 10Y	100C · 100Y · 80M	100Y · 100M · 80C	100Blk

131

NOTE: For technical information see page 6

100

90

80

70

60

50

40

30

20

10

0

Ossidet sterio binignuis
tultia, dolorat isogult it
gignuntisin stinuand. Flourida
prat gereafiunt quaecumque
trutent artsquati, quiateire
lurorist de corspore orum
semi uitantque tueri; sol etiam
caecat contra osidetsal utiquite

Ossidet sterio binignuis
tultia, dolorat isogult it
gignuntisin stinuand. Flourida
prat gereafiunt quaecumque
trutent artsquati, quiateire
lurorist de corspore orum
semi uitantque tueri; sol etiam
caecat contra osidetsal utiquite

Ossidet sterio binignuis
tultia, dolorat isogult it
gignuntisin stinuand. Flourida
prat gereafiunt quaecumque
trutent artsquati, quiateire
lurorist de corspore orum
semi uitantque tueri; sol etiam
caecat contra osidetsal utiquite

100Blk H/T • H/T's: **20**Y • **20**C 100Blk H/T • H/T's: **10**Y • **10**C

50Blk H/T • H/T's: **20**Y • **20**C 50Blk H/T • H/T's: **10**Y • **10**C

100Blk H/T • F/T's: **20**Y • **20**C 100Blk H/T • F/T's: **10**Y • **10**C

H/T's: **20**Y • **20**C H/T's: **10**Y • **10**C

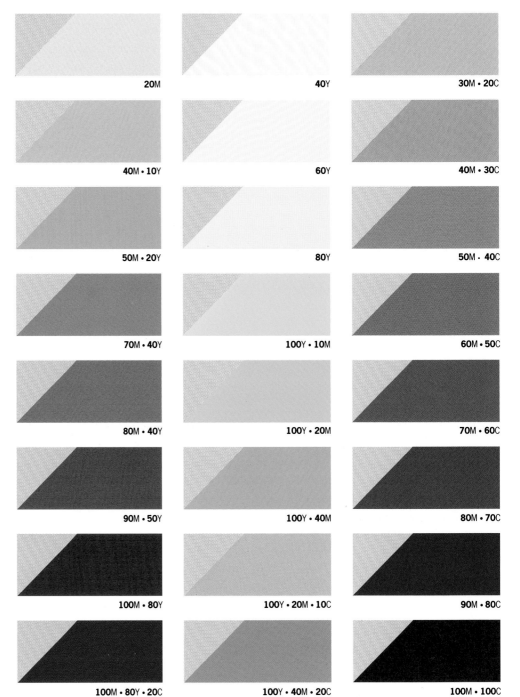

20M

40Y

30M · 20C

40M · 10Y

60Y

40M · 30C

50M · 20Y

80Y

50M · 40C

70M · 40Y

100Y · 10M

60M · 50C

80M · 40Y

100Y · 20M

70M · 60C

90M · 50Y

100Y · 40M

80M · 70C

100M · 80Y

100Y · 20M · 10C

90M · 80C

100M · 80Y · 20C

100Y · 40M · 20C

100M · 100C

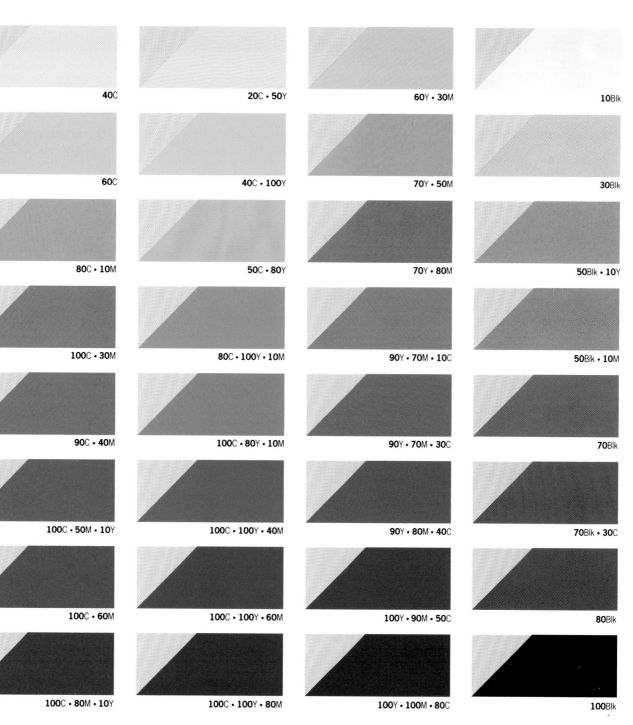

40C	20C · 50Y	60Y · 30M	10Blk
60C	40C · 100Y	70Y · 50M	30Blk
80C · 10M	50C · 80Y	70Y · 80M	50Blk · 10Y
100C · 30M	80C · 100Y · 10M	90Y · 70M · 10C	50Blk · 10M
90C · 40M	100C · 80Y · 10M	90Y · 70M · 30C	70Blk
100C · 50M · 10Y	100C · 100Y · 40M	90Y · 80M · 40C	70Blk · 30C
100C · 60M	100C · 100Y · 60M	100Y · 90M · 50C	80Blk
100C · 80M · 10Y	100C · 100Y · 80M	100Y · 100M · 80C	100Blk

NOTE: For technical information see page 6

Ossidet sterio binignuis tultia, dolorat isogult it gignuntisin stinuand. Flourida prat gereafiunt quaecumque trutent artsquati, quiateire lurorist de corspore orum semi uitantque tueri; sol etiam caecat contra osidetsal utiquite

Ossidet sterio binignuis tultia, dolorat isogult it gignuntisin stinuand. Flourida prat gereafiunt quaecumque trutent artsquati, quiateire lurorist de corspore orum semi uitantque tueri; sol etiam caecat contra osidetsal utiquite

Ossidet sterio binignuis tultia, dolorat isogult it gignuntisin stinuand. Flourida prat gereafiunt quaecumque trutent artsquati, quiateire lurorist de corspore orum semi uitantque tueri; sol etiam caecat contra osidetsal utiquite

Ossidet sterio binignuis tultia, dolorat isogult it gignuntisin stinuand. Flourida prat gereafiunt quaecumque trutent artsquati, quiateire lurorist de corspore orum semi uitantque tueri; sol etiam caecat contra osidetsal utiquite

100Blk H/T • H/T's: **40**Y • **30**C 100Blk H/T • H/T's: **20**Y • **15**C

50Blk H/T • H/T's: **40**Y • **30**C 50Blk H/T • H/T's: **20**Y • **15**C

100Blk H/T • F/T's: **40**Y • **30**C 100Blk H/T • F/T's: **20**Y • **15**C

H/T's: **40**Y • **30**C H/T's: **20**Y • **15**C

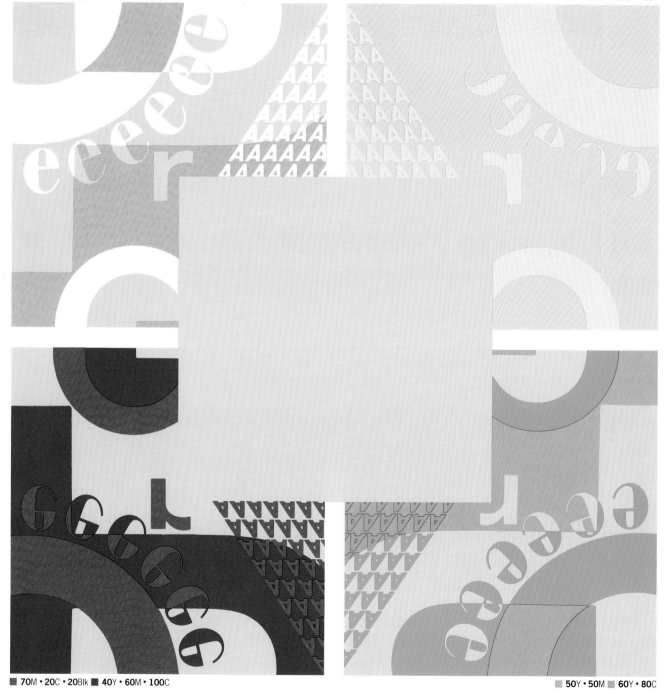

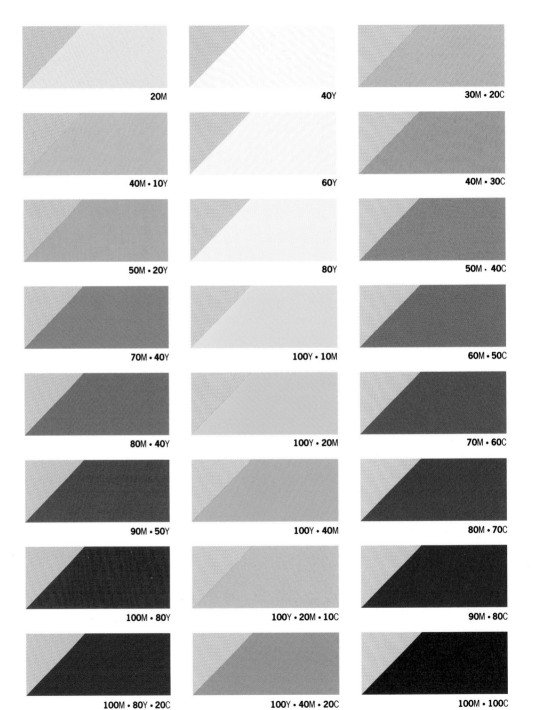

20M

40Y

30M · 20C

40M · 10Y

60Y

40M · 30C

50M · 20Y

80Y

50M · 40C

70M · 40Y

100Y · 10M

60M · 50C

80M · 40Y

100Y · 20M

70M · 60C

90M · 50Y

100Y · 40M

80M · 70C

100M · 80Y

100Y · 20M · 10C

90M · 80C

100M · 80Y · 20C

100Y · 40M · 20C

100M · 100C

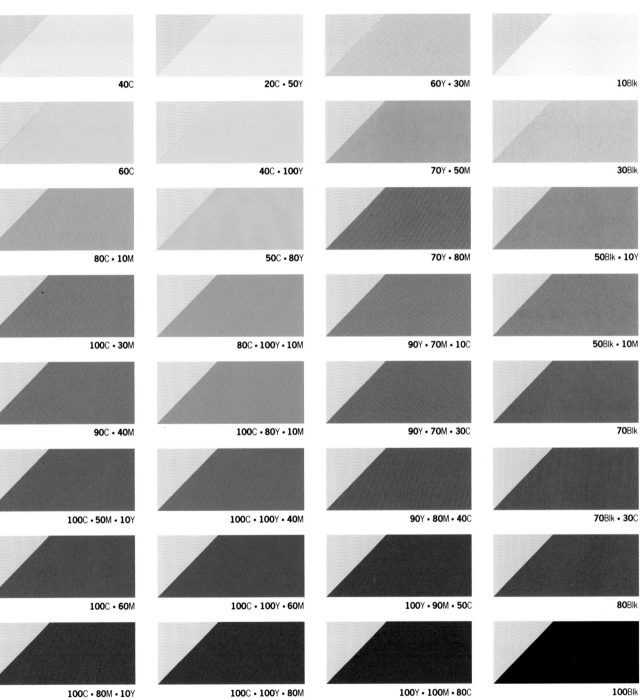

40C	20C · 50Y	60Y · 30M	10Blk
60C	40C · 100Y	70Y · 50M	30Blk
80C · 10M	50C · 80Y	70Y · 80M	50Blk · 10Y
100C · 30M	80C · 100Y · 10M	90Y · 70M · 10C	50Blk · 10M
90C · 40M	100C · 80Y · 10M	90Y · 70M · 30C	70Blk
100C · 50M · 10Y	100C · 100Y · 40M	90Y · 80M · 40C	70Blk · 30C
100C · 60M	100C · 100Y · 60M	100Y · 90M · 50C	80Blk
100C · 80M · 10Y	100C · 100Y · 80M	100Y · 100M · 80C	100Blk

NOTE: For technical information see page 6

Ossidet sterio binignuis tultia, dolorat isogult it gignuntisin stinuand. Flourida prat gereafiunt quaecumque trutent artsquati, quiateire lurorist de corspore orum semi uitantque tueri; sol etiam caecat contra osidetsal utiquite

100Blk H/T · H/T's: **30**Y · **40**C 100Blk H/T · H/T's: **15**Y · **20**C

Ossidet sterio binignuis tultia, dolorat isogult it gignuntisin stinuand. Flourida prat gereafiunt quaecumque trutent artsquati, quiateire lurorist de corspore orum semi uitantque tueri; sol etiam caecat contra osidetsal utiquite

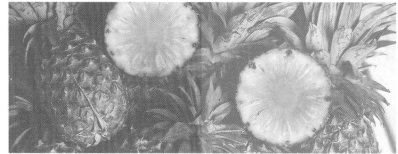

50Blk H/T · H/T's: **30**Y · **40**C 50Blk H/T · H/T's: **15**Y · **20**C

Ossidet sterio binignuis tultia, dolorat isogult it gignuntisin stinuand. Flourida prat gereafiunt quaecumque trutent artsquati, quiateire lurorist de corspore orum semi uitantque tueri; sol etiam caecat contra osidetsal utiquite

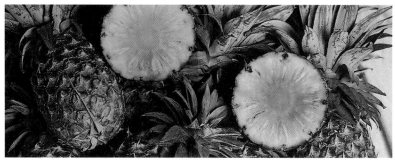

100Blk H/T · F/T's: **30**Y · **40**C 100Blk H/T · F/T's: **15**Y · **20**C

Ossidet sterio binignuis tultia, dolorat isogult it gignuntisin stinuand. Flourida prat gereafiunt quaecumque trutent artsquati, quiateire lurorist de corspore orum semi uitantque tueri; sol etiam caecat contra osidetsal utiquite

H/T's: **30**Y · **40**C H/T's: **15**Y · **20**C

Softest mint and pastel green belong to a family of colours that are versatile as background shades but depend on associated colours to bring them to life.

▶ The intensity of the red lettering is tempered by the subtle tones of pale green. The green in turn projects the black typeface. This combination of black type on green is a direct reference to the dollar. The entire image is made memorable through the unusual use of contrasting shades.

THE FROG BECOMES A PRINCE

Established businesses in a declining market are transformed into highly successful competitive operations each with a strong consumer base.

4

5

▲ The soft opal green forms a mist over the blue background behind the leaping figure. The green tint and the posture of the figure suggest the image of a frog. The blurred bright light conveys a sense of movement and the magical atmosphere of transformation.

▶ A pastel shade of viridian green forms the background for the title, allowing the subtle grey type to project, yet keeping to a palette that is complementary to the photographic image and sympathetic with the book's theme. These pastel colours discreetly, but clearly, draw the eye to the contrasting white background and herb green images.

◀ Sleeping Beauty is lying in a bed of twisting thorn. Her complexion and gown harmonize with the roses; her belt echoing the pale green of the leaves. Black type projects boldly above the peaceful scene.

▼ The theme behind this design is apparent through the use of opal green for the graphics. The green represents the countryside, helps to identify the client for this particular project and is sympathetic to the colours of the packaging.

The need to secure the anchor tenant for this prestigious West Country development demanded a unique proposition

Solution: A set of three handmade books bound Japanese-style presented with cassette recorder and promotional tape in a beautiful beechwood box

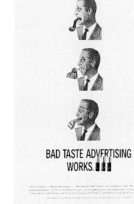

BAD TASTE ADVERTISING WORKS.

▶ The palest of green tells the story. It is used graphically to provoke a reaction through its connotations of money and illness.

Credits

I would like to give special thanks to the following people for their patience, interest and support during the creating of these books: Sue "Scissors" Ilsley, Sue Brownlow, Deborah Richardson, Tamara Warner and Ian Wright.

DALE RUSSELL

KEY: l=left, r= right; t=top; b= bottom; c=centre

p13: The Bridgeman Art Library.
p14: (t) John Heyer Paper Ltd; (b) Designed by Ian Wright.
p15. (tl) Design John McConnell, Pentagram; (tc) Giant Limited, London; (tr) Nucleus Design Limited; (c) Designed by U.G. Sato; (bl) Illustration by Kate Stephens, ABSA.
p16: (t) BMP DDB Needham/International Wool Secretariat; (b) Cover © Penguin Books, Ltd 1989. Cover photograph by Evan Fraser. Cover designed by the Senate.
p17: (tl) Designed by Smith & Milton Ltd; (tc) Designed by Smith & Milton Ltd; (tr) Minale Tattersfield and Partners International Design Group; (c) Reproduced courtesy of the Department of Energy/Giant Limited, London; (br) Milton Marketing (Advertising and Design) Limited.
p18: (t) Publicis Focus; (b) Minale Tattersfield and Partners International Design Group.
p19: (tl) Lewis Moberly Design Consultants; (tr) Saatchi & Saatchi International; (bl) John Heyer Paper Ltd; (br) Fitch RS plc.
p20: (tl) Design Mervyn Kurlansky, Pentagram; (tr) Neville Brody Graphic Design, London; (br) Design Alan Fletcher, Pentagram/Collage by Peter Blake.
p21: (tl) DRG Paper and Board; (tc) Design Mervyn Kurlansky, Pentagram; (bc) The Small Back Room plc; (tr) Minale Tattersfield and Partners International Design Group.
p34: (br) Fitch RS plc.
P35: (t) Blitz magazine; (bl) Jean Paul Gaultier, Paris; (br) Trickett & Webb.
p44: (t) Aura Design; (b) Client – International Flavors and Fragrances/Photographer Alan David – Tu/Agency – International Partnership/Art Director – Peter Bristow.

p45: (tl) Robert Opie; (tr) Decorative Alphabets Throughout the Ages by Pat Russell pub. Bracken Books; (br) Giant Limited, London.
p54: (tl) Fitch RS plc; (tr) Giant Limited, London; (bl) Blitz magazine.
p55: (tl) Lewis Moberly Design Consultants; (tr) David Davies Associates; (br) Giant Limited, London.
P68: (t) Open Letter by Loose Tubes is released on Editions EG/Giant Limited, London; (bl) Georgia Deaver; (br) Design John McConnell, Pentagram.
p69: (t) Designed by Masatoshi Toda; (bl) Giant Limited, London; (br) John McConnell, Pentagram.
P82: (l) Design John McConnell, Pentagram; (t) Saatchi & Saatchi Advertising; (b) © 1987 Sanrio Co., Ltd.
p83: (tl) Minale Tattersfield and Partners International Design Group; (bl) Dire Straits Overseas Limited/Photographer Deborah Feingold; (tr) Design John McConnell, Pentagram; (br) Minale Tattersfield and Partners International Design Group.
p104: (l) Saatchi & Saatchi Advertising; (tr) Client – International Flavors and Fragrances/Photographer – David Hiscock/Agency – International Partnership/Art Director – Peter Bristow; (br) Design David Hillman, Pentagram.
p105: (t) Shisheido Co., Ltd, Tokyo; (c) Saatchi & Saatchi International; (b) Designed by Masatoshi Toda.
p114: (l) Vignelli Associates, New York; (br) Cranbrook Academy of Art: Design – Katherine McCoy and Andrew Blauvelt.
p115: (tr) Neville Brody Graphic Design, London; (b) Minale Tattersfield and Partners International Design Group.
p124: (tl) Georgia Deaver; (tr) Newell and Sorrell; (b) Designed by Smith & Milton Ltd.
p125: (tl) Printed courtesy of the Department of Energy/Giant Limited, London; (tr) Reprinted by permission of Margaret K. McElderry books, an imprint of Macmillan Publishing Company from Noah and the Great Flood by Warwick Hutton. Copyright © 1977 Warwick Hutton; (b) Giant Limited, London.
p142: (t) Design David Hillman, Pentagram; (bl) Trickett & Webb.
p143: (tl) Reprinted by permission of Margaret K. McElderry Books, an imprint of Macmillan Publishing Company from The Sleeping Beauty by Warwick Hutton. Copyright © 1979 Warwick Hutton; (bl) Saatchi & Saatchi Advertising; (br) The Small Back Room plc.

" *The very pink of perfection.* **"**

Oliver Goldsmith